GIBBOUS

MOON

WINNIPEG

Dennis Cooley

GIBBOUS MOON

Michael Matthews

Picturing Words, Wording Pictures

by Robert Enright

In 1982 the French literary critic, Nicole Boulestreau, coined the term *photopoème* to describe a collaboration between poet Paul Éluard and photographer Man Ray. "Facile" (1935) was a collection of 12 of Man Ray's photographs of Nusch Éluard, and a matching number of poems written by Paul about his wife and muse. Boulestreau's essay remains an important one, but the practice of poets and photographers collaborating existed before she named it.

In 1875, Julia Margaret Cameron chose 24 full-size prints from 245 exposures to illustrate the two volumes of Alfred Lord Tennyson's "Idylls of the King", his monumental poetic telling of the Arthurian legend. In 1923, Vladimir Mayakovsky's poems and Aleksandr Rodchenko's photomontages were combined in "Pro eto. Ei i mne (About This. To her and to Me)"; in 1948, poet Edwin Denby and photographer/filmmaker Rudy Burckhardt published "In Public, In Private", a collaboration focused on the life and art of New York; the Gunn Brothers, poet Thom and photographer Ander, published their collection on Londoners, called "Positives" in 1966; and Ted Hughes combined a sequence of poems on the landscape and people of Calder Valley with photographs by Faye Godwin in "Remains of Elmet" in 1979. Each of these books (and I could add dozens more), treats the relationship between the two art forms with different emphases and intentions.

One of the most interesting American examples of a book of photopoems was "Land of the Free", in which Archibald MacLeish arranged his poems around a selection of 88 images by members of the FSA (Farm Security Administration), including Dorothea Lange, Walker Evans, Ben Shahn and Gordon Parks. Published in 1938, MacLeish described it as "the opposite of a book of poems illustrated by photographs. It is a book of photographs illustrated by a poem." His distinction draws attention to a vexing question that comes up in all collaborations: what is the desired balance between the contributing artists and art forms?

In their splendid collaboration "The Gibbous Moon", photographer Michael Matthews and poet Dennis Cooley have solved the whole problem of balance by addressing it in halves. The book contains 78 poems and 81 images. The poems were written between 1982 and 2021; the photographs span a year-and-a-half, beginning in February, 2019 and ending in September, 2020. The idea for the collection and the matching of image to poem belonged to Matthews. In Cooley's estimation, "Overwhelmingly, he has been the leader and the doer." The numerical equivalence that Matthews determined opens up the book to a range of possible 'reads' and by paying equal attention to the qualities of their respective languages, the two artists have been able to find a third language in those revealed spaces. The photographs and poems in the book are like the cave paintings at Lascaux and Altamira described in "excerpt": taken together, they are "ringing with colour and contour".

Any discussion about a poem and image combination would reveal a cluster of suggestive compatibilities. Some of the connections are

literal and the correspondences relatively straightforward; the companion image to "a speaking" shows evidence of "clefts and fissures" and in "july a fever", "the wrinkled green air" and the black trees included in the poem are clearly readable in the photograph.

The correspondence between poem and image is more complicated in "phases"; the poem suggests possible shapes and colours for the moon – it is pewter or caramel, it is "more yellow than a dog's tooth" or "an onion pickled in gin". Matthew's image shows a glowing yellow orb on the left-hand side and contained within a floating black rectangle are 18 close-toned circles, variations on the phases of the moon. These circles are incorporated into a textured grey and yellow background, a palette that includes a hint of teal and hunter green and, on the lower right, there are thin black lines, a rendering of the scratched initials mentioned at the end of the poem.

Where "phases" presents matching indications of shape and colour, the image for "their eyes stinging with salt" becomes a dramatic visualization of the poem's implied narrative. There is something Homeric in the lament for the lost figures, "wrecked on the rocks/ in strange voices singing." In the accompanying image, Matthews creates a magnificent red-gold seascape, playing Circe to Cooley's liqueured-up Odysseus. In their respective distillations, they plug into something mythic.

The short lyric, "streets at night", presents the working of image and poem with an acute economy. It opens with, "a stem of light/ blooms inside darkness" and closes with three lines that have the arrangement and compression of a haiku without the form's syllabic exactitude: "tail lights sucked/ into the street/ a red gash on the night." In his photograph, Matthew's red line arcs across the surface of the image and performs a double duty, as the blooming stem of light, and as the stitched line that sutures the night's red gash. His image articulates a jaggedly exquisite simplicity.

Matthews is particularly effective in making images that convey a sense of visual drama. They often read as land or seascapes. The rose-inflected splash in the foreground of the image for "their eyes stinging with salt", could be the place of rock-wrecking, described in the poem. He has a Turneresque instinct for colour and movement; the image for "trawlers" carries the same spectacular quality. The poem tells us the fishermen, "leap on to the deck/ in tumult or quiet luminescence" and Matthews orchestrates an equivalent leap in the sea's grey-white crash of colour and the sky's calming green luminescence. As a viewer, you become "a traveller on the sea" of Matthew's photograph.

He has perfect pitch in deciding the tone of the image he links to each poem. In "orchard", the poet goes wild and juicy with colour and scent and taste, ending the poem with his rising voice, "soft as plums/ warm as rum/ in the lilac air". Cooley's synaesthesia is a virtuoso riff, the most radical example of his desired sensory poetry. Matthew's response is to hold back, to play rhythm to his collaborator's lead vocal. His image is an elegant, blended suffusion, with an off-centre blush of green plum and a touch of lilac, where the blue sky meets the red earth.

In Matthew's image for "figures 1", it is possible to read the black lines with gorgeous tracings on the translucent surface as evidence of the skating figures "inside the cold-air rink", and as the marks they make "scratch notes on the frozen surface". But nothing in listing those literal associations addresses the fragile and poignant quality of the image. Matthews doesn't accept erasure, as the poem laments, but instead records a palimpsest. His reading makes memory visible, and the palimpsest is its trace.

Cooley, for his part, encapsulates his vision in a tidy three-part reduction; in "far shores" he writes about "oceans on far shores/ little seas at your ear/ the words on a string". In one sense, his poems string you along and you are helpless not to be as delighted with the journey as he is. "The Gibbous Moon" is overflowing with the play of language. He loves sound-bridging, so he'll connect similar words; the lines "…said you would shed/ light shred shadows" mobilizes a trio of rhyming words that both holds the poem together and moves its meaning forward. In "anemones", "in the end we will/ without fame or flame/ Drown". In "remember", when everything began, it "rose from the shale from the shade" and in "trawlers", things "wrap themselves around a secret/ secrete a lacquer of moon". This tone-leading is one of the strings he moves inside the poem. In "the dance", he composes a brilliant poem about bones. "For a moment", he writes, all the boneswould enter the dance "in skim and scud". It's as if he conjures up poet Robert Duncan by way of a kenning. Duncan gave us generative advice in "The Opening of the Field" (1960), when he told us that "if you don't enter the dance, you mistake the event". There is no mistake here; the event is one in which all the bones are "jingling the flesh" and Cooley continues the unending dance in "bone house", where he directs language to do some fancy dancing, moving from "casting nets" to "castanets in the morning when you run/ into a nest of yellow wild as yarrow". The whole poem is a sound sensorium, the words performing an aural choreography. For his role in the photopoem *pas de deux*, Matthews builds a complex and dazzling architecture, as if Mondrian had a horror vacui and filled all his space with nervous, wobbly lines. Its linear connections are the visual parallel to the poem's soundings.

Matthews is a proponent of Ansel Adams' declaration that, "you don't take a photograph, you make it" and, as a result, Photoshop is an essential part of his work. "It allows me to refine and shape ideas in amazing ways". In choosing an image for "wonders", a poem that includes girders, broken parts and sticks and stones, Matthews settles on a photograph with a layered constructed history. "It was made from several different sources, including a photo of a small wooden building on the Lofoten Islands, a photo of a temple in Myanmar, two or three photos of general background textures (walls and paper) and several mask overlays with hand-painted brushstrokes and a combination of hand-drawn masks and luminosity masks. All together, ten different layers". The image is a gorgeous bewilderment. The epigraph that opens "to make the stone", is from Percy Bysshe Shelley: "Poetry lifts the veil from the hidden beauty of the world", he writes, "and makes familiar objects be as if they were not familiar". Matthews visual poetry operates within this conceptual and optical territory as well, although he is just as capable of reversing the process by taking unfamiliar objects and making them familiar. Regardless of how he approaches the problem of making an image, what he comes up with is unfailingly redolent with beauty.

In her essay on the *photopoème*, Nicole Boulestreau locates the progression of meaning, "…in accordance with the reciprocity of writing and figures: reading becomes interwoven through alternating restitchings of the signifier into text and image". It is worth noting that the trope of the weave and the stitch, recurs throughout the poems in "The Gibbous Moon". Cooley applies the metaphor in vastly different scales; in "needle work", it is mosquitoes who "wanted with their needles and thread/ to be in on the naked fabric of life"; in "reading the sign" the participation is cosmic when "the sky in flashes of lightning" is "sewing hot sequins on your blouse". But it is "seamstress" that makes the most

telling connection with the sewing metaphor. For the seamstress the pen is a pin with which she "begins to darn the ink to couch her words…/ she is taking measures to stitch earth and sky/ which every evening tugs and threatens/ to tear away in a stiff wind." The conceit is just right because the poet, too, takes measures, "to fasten things into place" and to effect that binding, he extends the practical measure to an aesthetic one. He applies an "intricate embroidery", and Matthews follows suit in his explosively radiant image where stitch marks run across the green and red and golden surface of the photograph.

All this stitching has an aesthetic utility. "The Gibbous Moon" is a blood-conscious book; as a result, the colour red is dramatically evident in a number of the most powerful photographic images. (The image for "poppy" seems infernally lit from within; its ember-like glow is so intense that it scalds the eye). Red is the apposite colour for a book that centres around what "piscene" calls, "the hydraulics of life and death". In "the colour of your dreams", the angels whispering in your ear communicate "small streaks and spatters of blood/ flashing with crimson desire"; the poem is accompanied by an image that shows a grey stony surface with a tracery of attenuated rusty lines and a meandering, delicate fracture. Here the "crimson desire" is understated, but "riding into sunset" raises the colour temperature; it concludes with the lines, "every evening/ the world explodes/ and the blood runs down/ the rim of the world". This poem is a point of departure for one of the book's most eloquent word and image combinations. It embodies "the crimson of travelling" and were it to have a sound, it would be the promise of "hot intravenous music".

"The Gibbous Moon", poem and image and book, is a seamless triumph. What Michael Matthews and Dennis Cooley have accomplished is to make reading and looking aspects of a complementary phenomenology. As readers and lookers, inescapably, we become their collaborators. "Don't blame me", the poet warns us in "strange ms. found in a bottle":

you have brought me here
it is you reading
these are your words too.

Dedication
❧

For Sterling and Dana
— Dennis

For my brother John. I miss you.
— Michael

lights fall through
onto dreams

night lights

pass over
each its own planet
feeds on the blue zones
a glow on the chromosomes

hold spots of fire
in their hands
before their faces
not knowing
the lost end of time

our lady of the shadows

said you would shed

 light shred shadows we were wrapped

and skated in

 your breath

 i should have said

when you stir

 the air squeaks

before you say

 it's snow

and shake us

 from the darkness

vapour rising from our mouths like locomotives

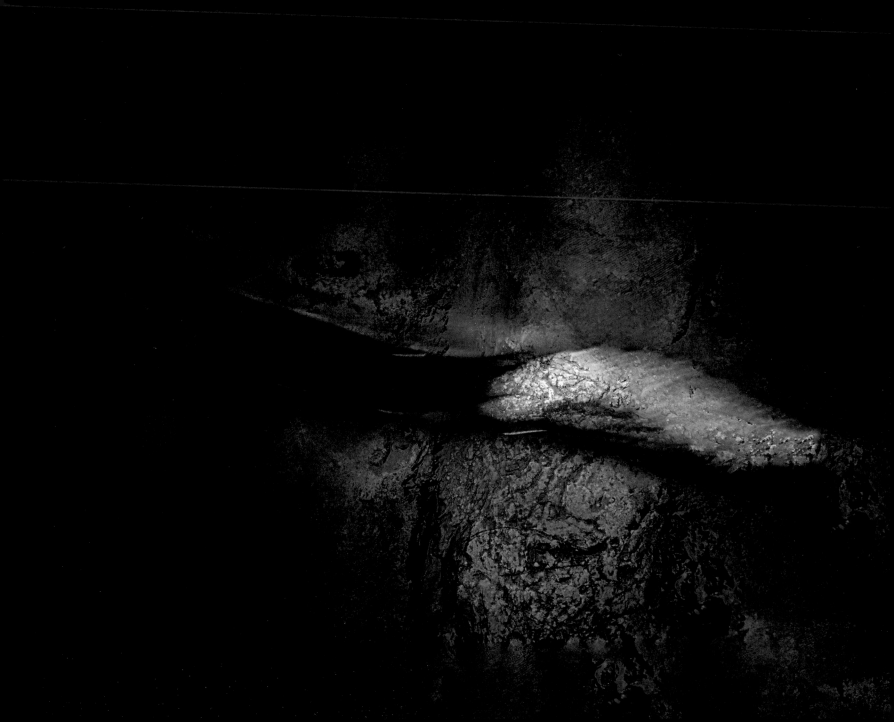

gas lantern

night goes dark
so slow and raw
it could be felt
oil soaks into

could be burnt syrup
a time of delays
relays burnt out

when they turn up
the fuzzy light the lamp
fills like a lung
hhffhff hfhhfff
from the day's dust

its eye grows a little
brighter a little rounder

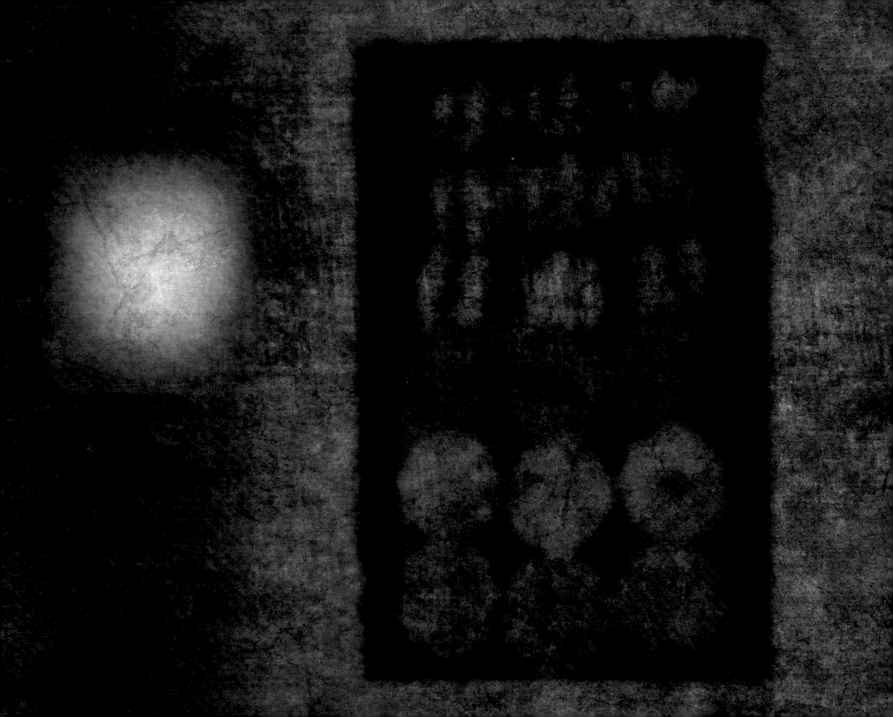

phases

turned to pewter grew rounder
more yellow than a dog's tooth

/ the moon
slips from the night
in a sleepy burp

yes, he said, he thought he could
feel it on his skin, a caramel light

they decided the moon
was an onion pickled in gin

and in the morning
sun scratches
its initials
in your
ear

midnight blue

a pod on the stem of night
 peel back
 the dark
 you are under
 it is
raining
 gently
 with light

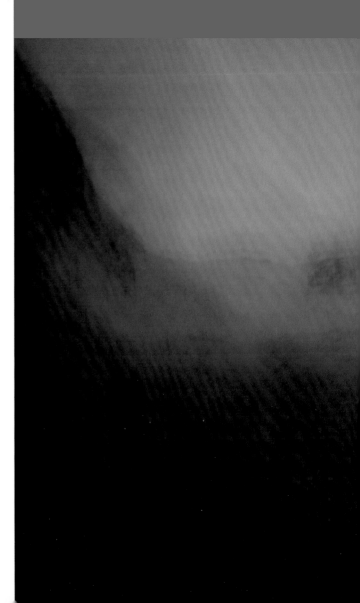

night flight

the lock & canals they skate upon

nexus of lights drift overhead
germs of stars & planets

 /blip
 blip/

 faint sound
 when they come down
 airsick

 when they are
travelling light

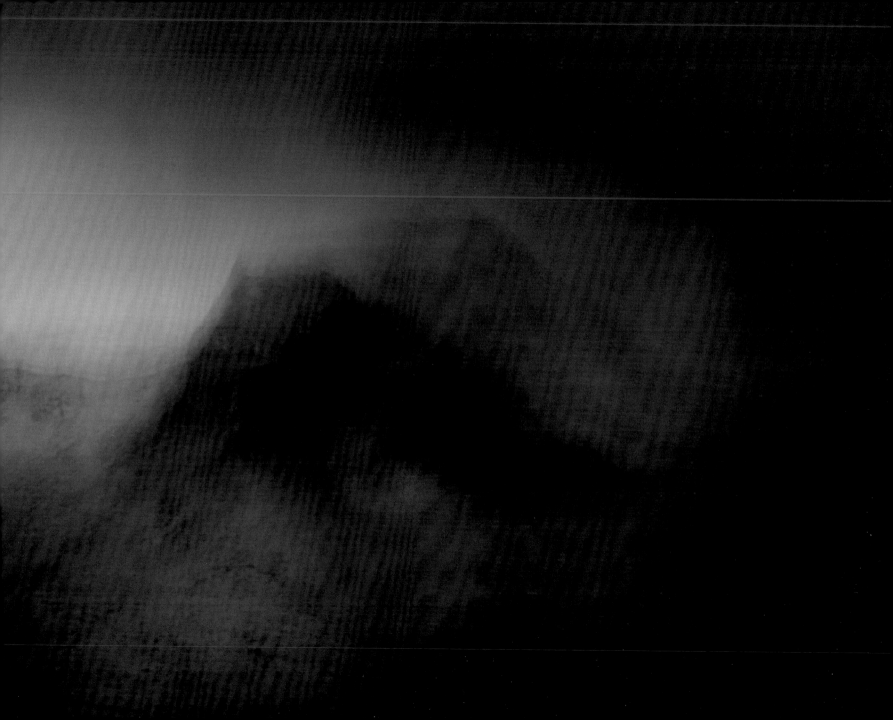

taking off

goldfish (we

 swim

in(nights belly

 tentacles

plants washed

 strange planets

 below

3 billion miles

 new as an angelfish

plane a

are in

with

cars throw

feed on

ashore

above or

somewhere
in rivers to neptune

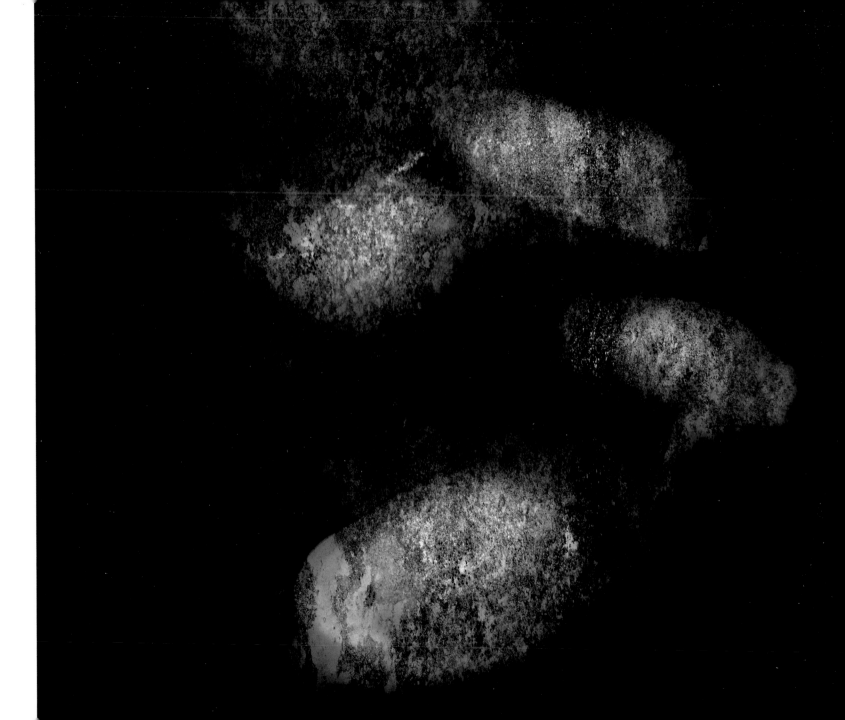

july a fever

July was for
ever was full
was wind & sky &
forever & forever a fever
in the wrinkled green air
days & days to get there
& never arrive

the sparrows spare
for all their quickness
their own kind of sorrow
fever fever
quirky little things

the five trees on fire
the small elms seething
black trees that burn into eternity

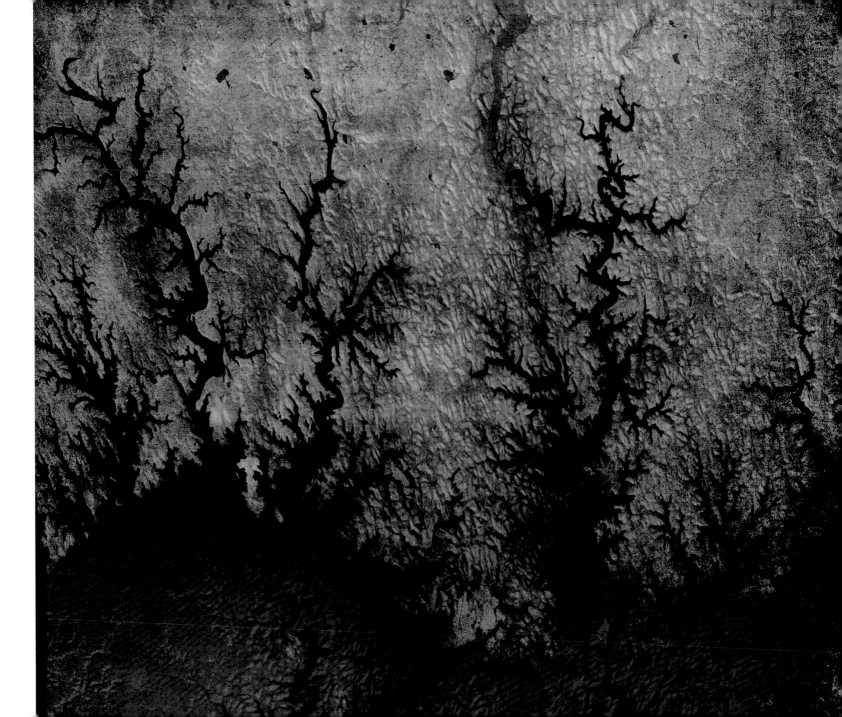

their eyes stinging with salt

> darkness they slept
> and drowned in sun
> light its iron
> grip no more
> than a sip of sand
> a taste of grand
> marnier for those
> who wrecked on the rocks
> in strange voices singing

> & never came back

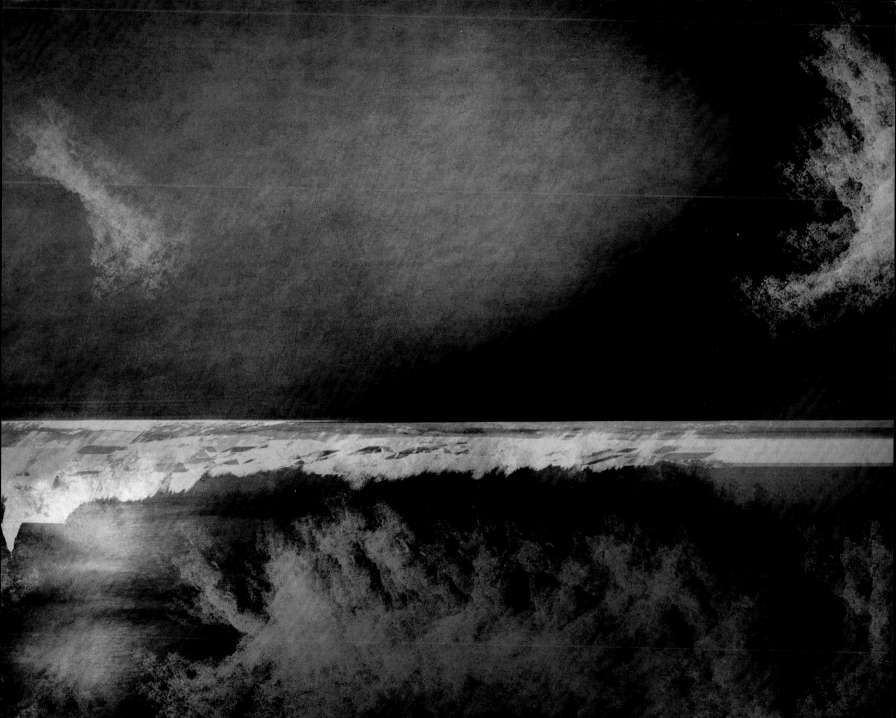

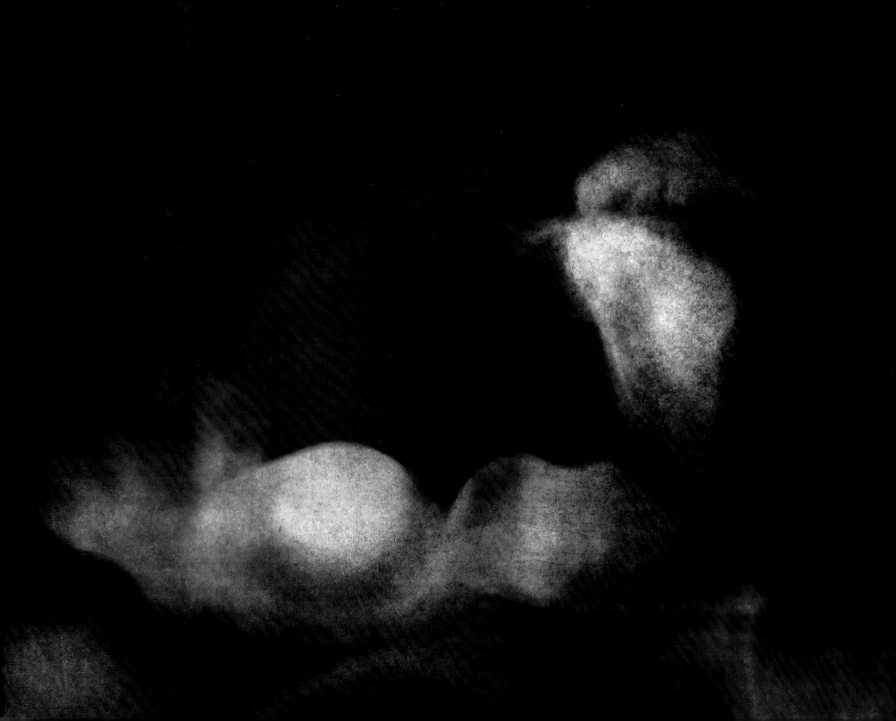

anemones

where's the harm
in the end we will
without fame or flame

Drown in yell
ow memes
and Me mories
Ever & A
non Y
mous as an

Emones Aries
arisen in an ebony sky
we are drawn in

one an other
'S charms

Crying out
Like love
Rs or ene
Mes

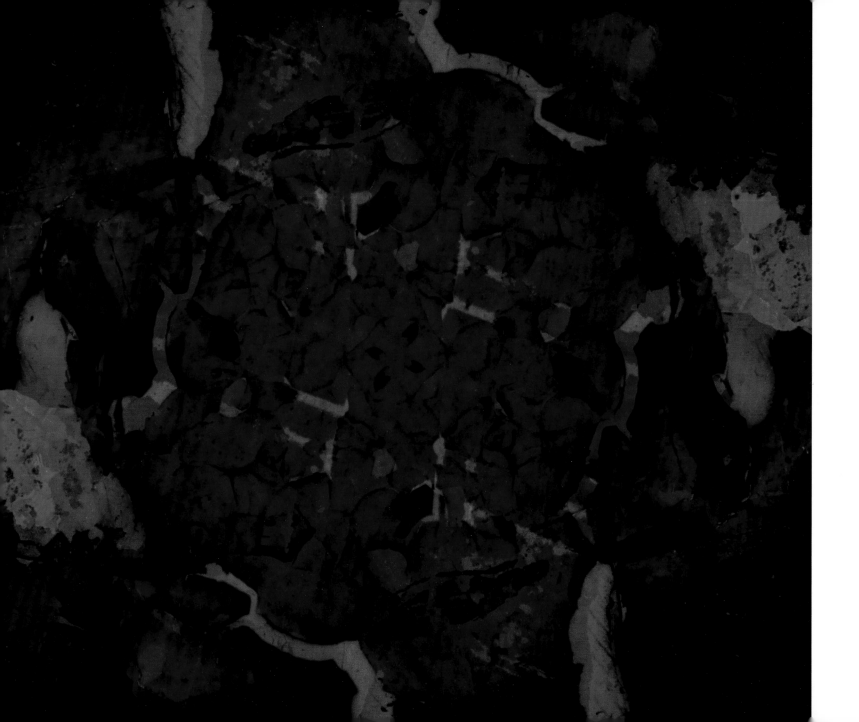

poppy

and then the poppy
a wick in wind
bright lipstick
/brighter

the inside of a peach
you run your finger over
the slippery membranes
all the wet words
in your mouth

they will fail to open
fall swiftly
between and crash
and sometimes touch

a poppy
red on black
blown out over night

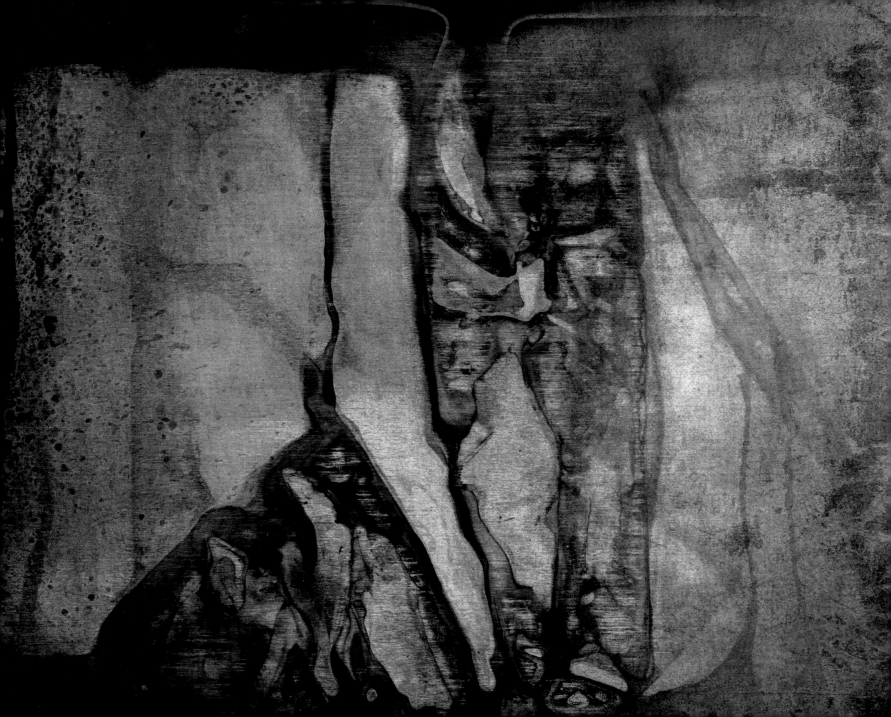

a speaking

through clefts and fissures
the words hidden
where he sleeps in a dark box

 she a chatelaine with a bright key
 he could live in her permissions

 let me in let me in she has said
 when she sweeps away the light
 and he weeps in the night

trawlers

below hull and sail small disturbances
they wrap themselves around a secret
secrete a lacquer of moon

they cover themselves in shellac
hoping to be found
by travellers on the sea
and in love taken home

 those on board
haul them up out of the dark
where they leap onto the deck
in tumult or quiet luminescence

where prodding & sorting people
stand over them in teeth & eyes
until they are drowning in light

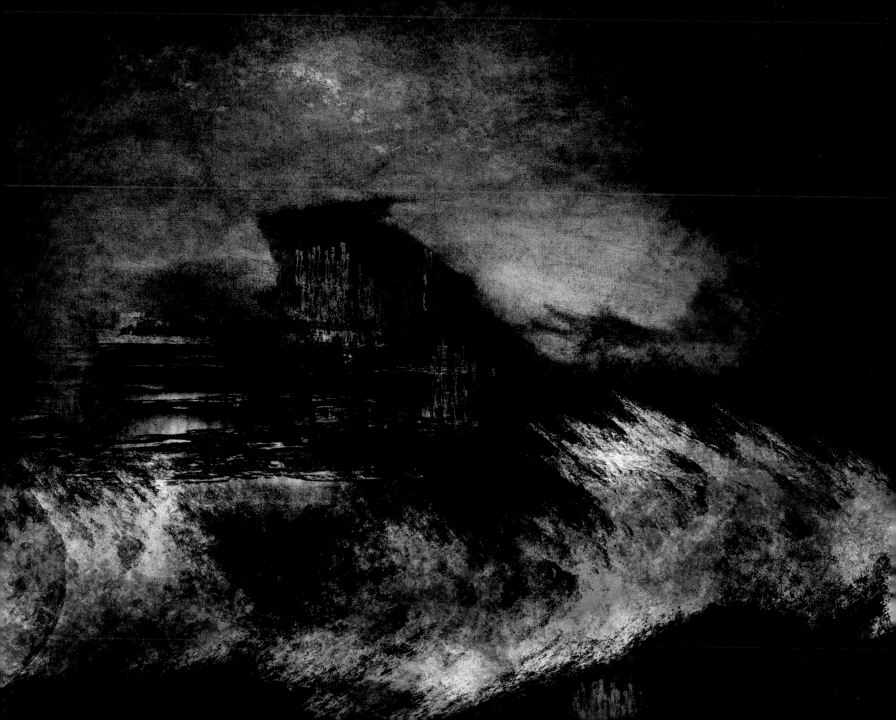

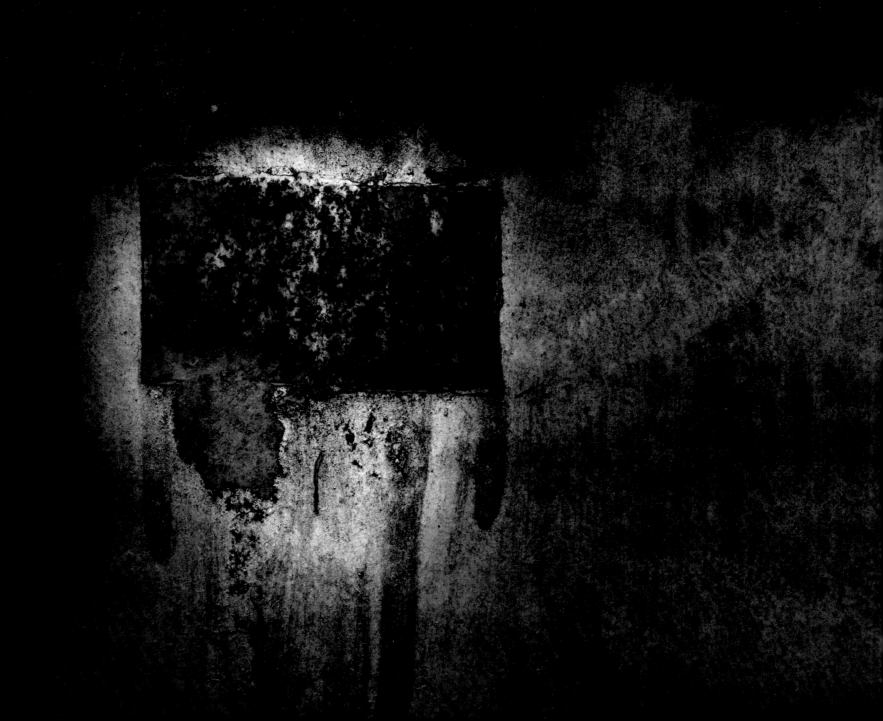

snow clearing

 & then the machine

 enormous wonderful machine

 rose about us

 boring holes in winter

 parting the dead

 land leaping to life

 huge machine harvesting winter

the wind the bright curving wind

& in it the white flowers blowing

 blooming from its ears

 machine that drove our dreams

 every winter through winter

 & after we would burrow

 into the white gardens

 it laid out in high banks

 let light in & wind

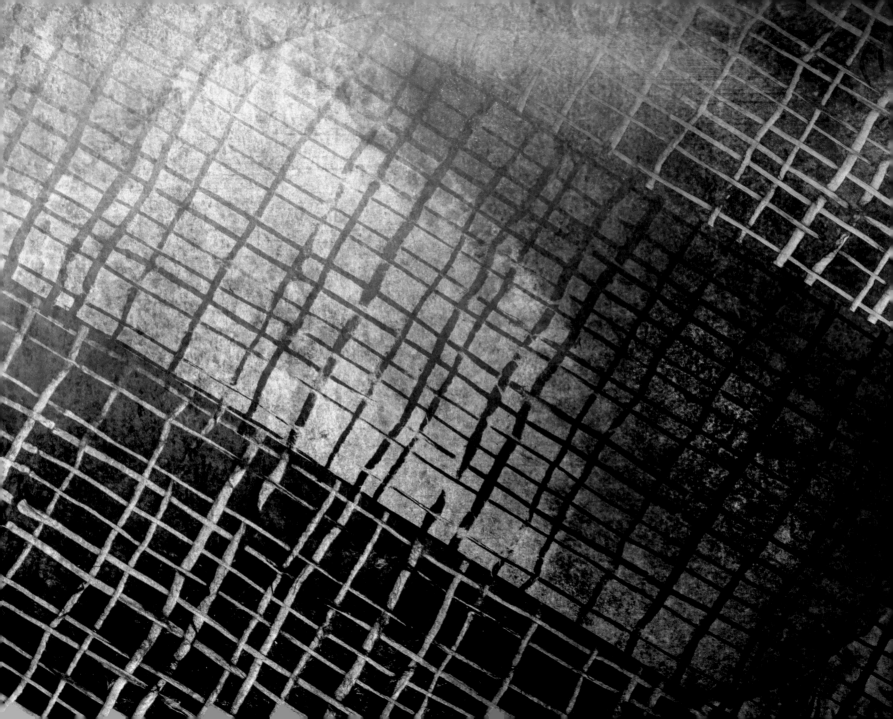

needle work

when they washed ashore
on shining black filaments
they gathered at the window
greater than the inquisitors of Cordoba
made the sounds of glasses rubbed
 their hum cathedral

 their sewing machines revved
 until they smelled of hot oil
 and they poked through the screens
 whined in high and febrile voices

they wanted with their needles & thread
to be in on the naked fabric of life
the fiery prick of the moment

wonders

 where have they gone
 by the trillions why aren't they
 stacked in girders, the broken parts,
 the border-jumpers we always were
 crowding so badly there'd be
 nowhere to step after 5 or 6
 billion for 7 or 8 billion
years the molecular clocks ticking

 here ↵
you might wish
to name them
all the sapiens

 ⇒ names and dates
 ⇒ the drag of their bones
 ⇒ that time splinters

the sticks & stones that broke
the bones that lived inside
the jaws that filled with teeth
the heels that kept time
the wind that saw its breath &
 snapped them under
 deeper than caskets

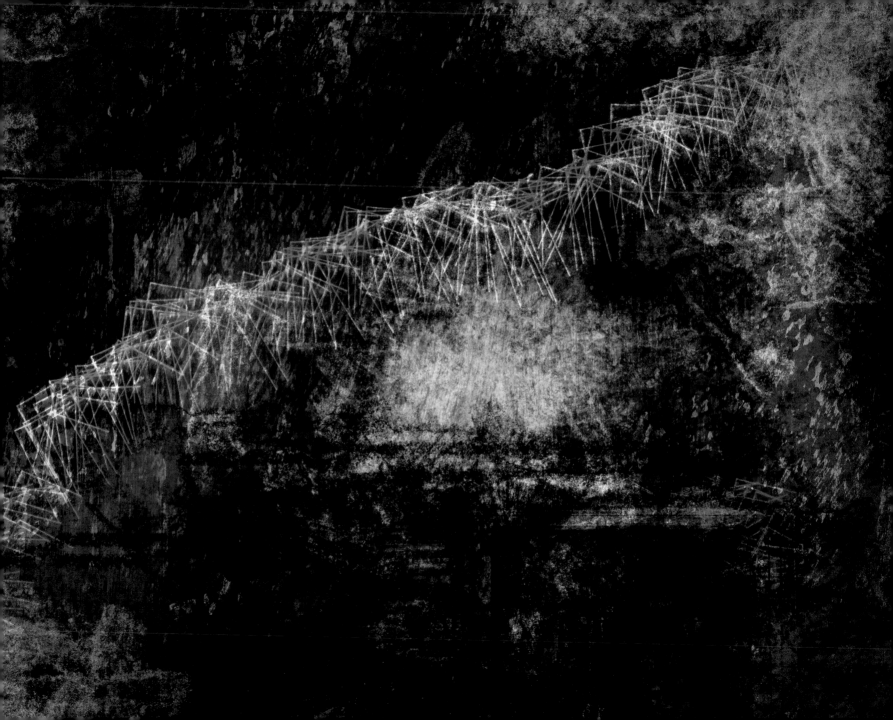

burnout

and the merry-go-round
 flings
faces at you

and yet it will i know
fall back on itself
a black
metal smell
when it has burnt
itself out

 flies where they die
 in a hot burn on the sills
 lie where the windows
 have spilled them
 a handful of raisins

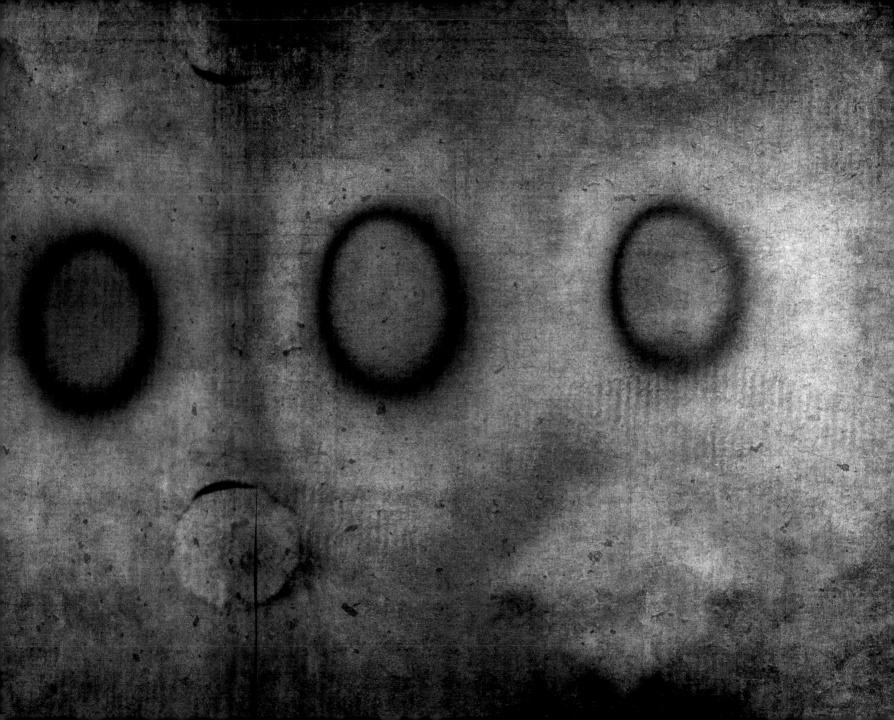

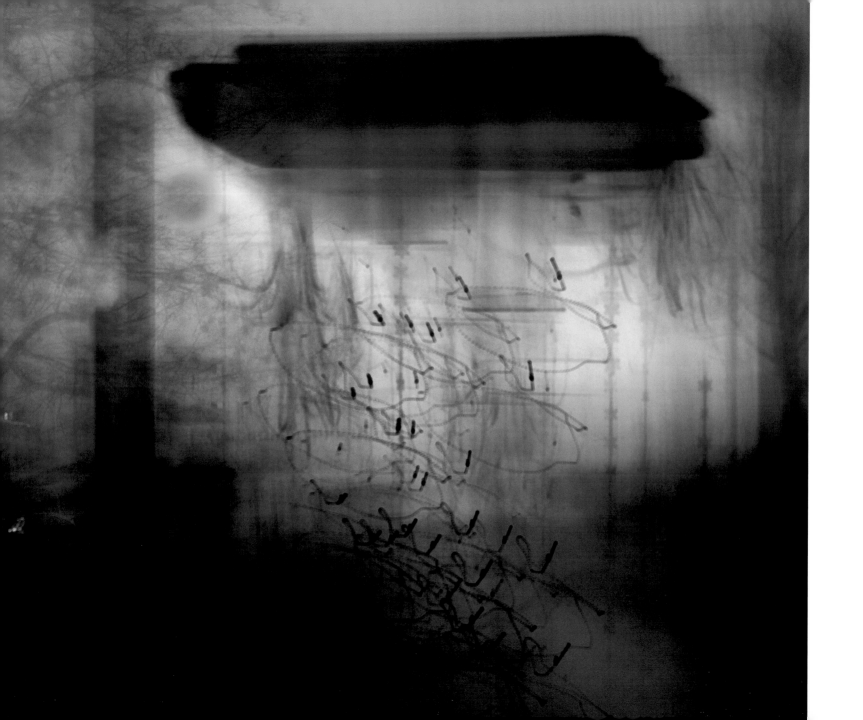

figures 1

every night the snow brightens
inside the cold-air rink

they scrape and whizz
and bump their heads
some thump, leave black
marks on the boards

 within which she
 leans and listens

 the place on which
 she can scratch notes
 on the frozen water

 knows others will swoop & scuff
 that they will erase
 until little remains
 of what she has
 left behind

remember

when first it started, everything began
rose from the shale from the shade
cold weighing as if they
were timid or ill-timed

 where their eyes first broke
the Precambrian Shield, its huge shoulder
 & forests became

the seas crowded with saline
a film over their sight
what they see sinks back through salt
their fossil eyes filling with silt

throw back light
until we see in the dark
as if we were
spearing fish in the river

a white streak, chalk on the black
a dim figure moves
the dark at the heart of night

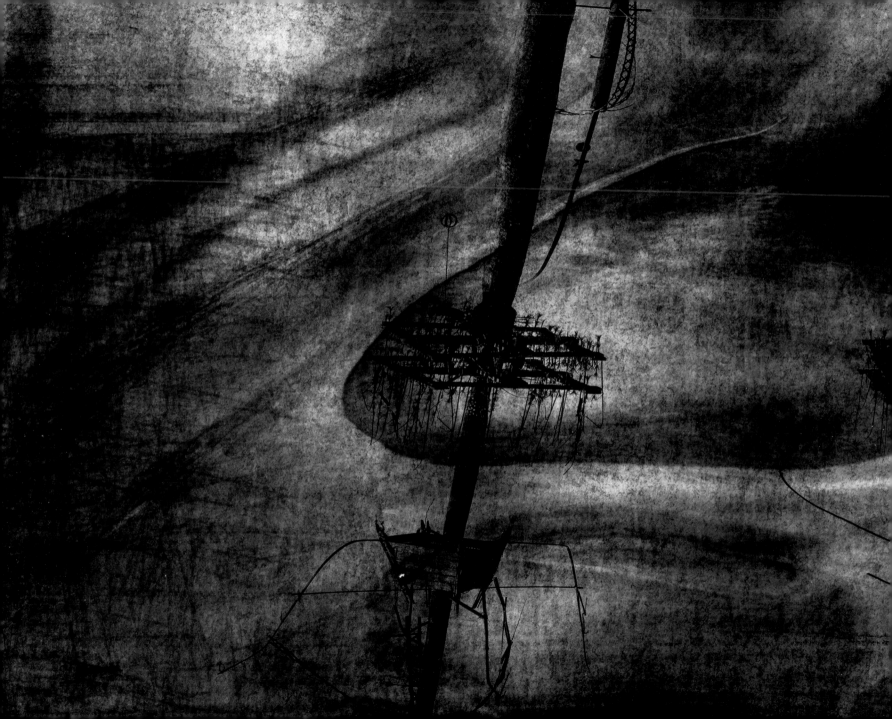

zodiac

the sun does not intend
the wires or the gates
through which we hear
the wind squeeze us to sand

and the world
sizzle & go out

pebbles at the speed of light
rattle the window
the surfaces pitted

the brain exfoliates
in blue halations
swollen with as many
neurons as stars in the sky

the whole shooting works
in fits & starts
flares & dies

the tiny furnaces

before we snuff it
we up & for a second sing

give her a spin
give it a whirl
give 'er a sting

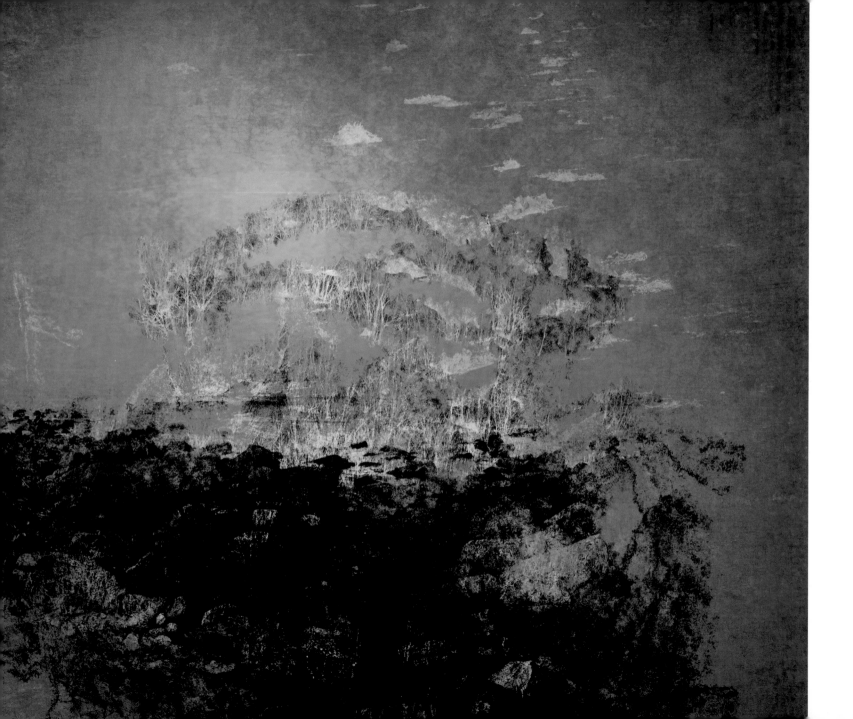

the very sun

 the doctors scratching
 their heads over the un
 treatable & terminal burns

wondering who it is
swings the panels
her face a bright planet
falling out of the sky

 waiting to find
 if it has left little
 bits of shrapnel
 which when he
 moves some
 times feels

the first day

brightness of ice
　　filling with snow
so white it could be milk

when the sun has slipped
　　over the edge of breath

　　this is the first day the flakes
　　　　so radiant they could be stars
　　　　　　the new-
　　　　　　　　fallen snow

what has been written
eases the tricks
you have been practising

　　an owl drifted　　south of its range

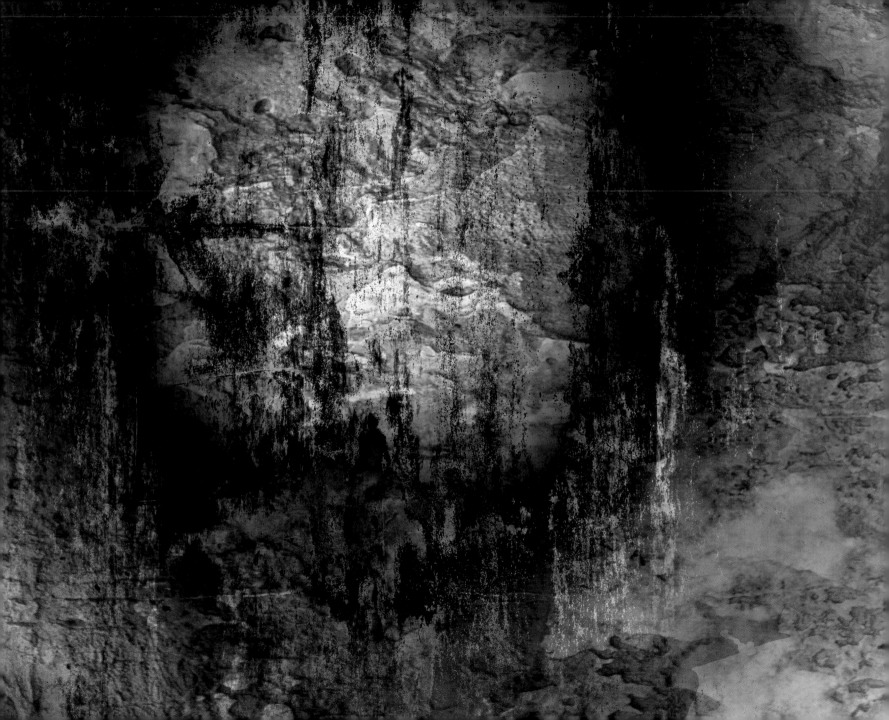

milky way

at night they come out
high on aether

beneath a fuzz of light
people bend their necks to see
the nebulae in their eyes

to watch the stars browze
& the wind fills up with commotion

blue chamber

a black crab
clambering over rock
straight out of fire
straight out of gold
spreading like lichen

has left nebulae glittering and whipping
the shrivelled seeds skittering
farther than stars on the first day

all night the moon
hangs in a blue chamber
spills balm on the black patches
fungi have laid over
the dark recesses of our bodies

buff the air to thinness
press brightness out of dimes
compress us to dimness on the other side

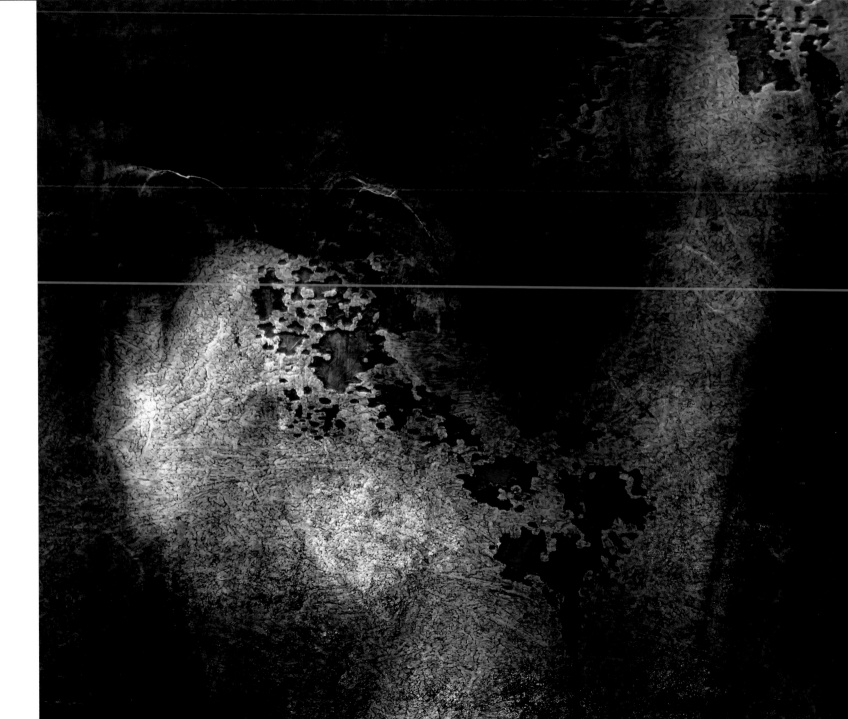

strange ms. found in a bottle

begins to disperse

for all to see the awk

words where they are laid

the gawky chickens scratching

we too good and ready

/more than ready

to hatch, to tilt, to slide,

a green bottle, an ark,

what can i say

don't blame me

you have brought me here

it is you reading

these are your words too

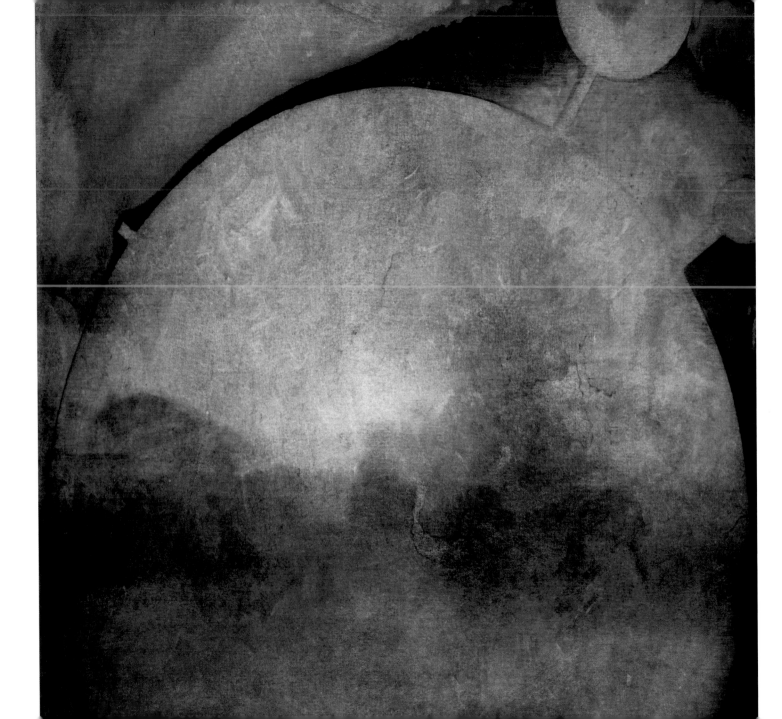

dog in snow

you love the swoops & contours
 their downhill tumble
the loping that is hill that is dog
 the day a wagon of brightness

 every morning
 you track the words
creatures sniff & dig in
 the dazzle of snow
the shine your breath spills

 laugh when the hill
 follows you down
for the sounds under & upon
 the quiet of the new
 fallen snow

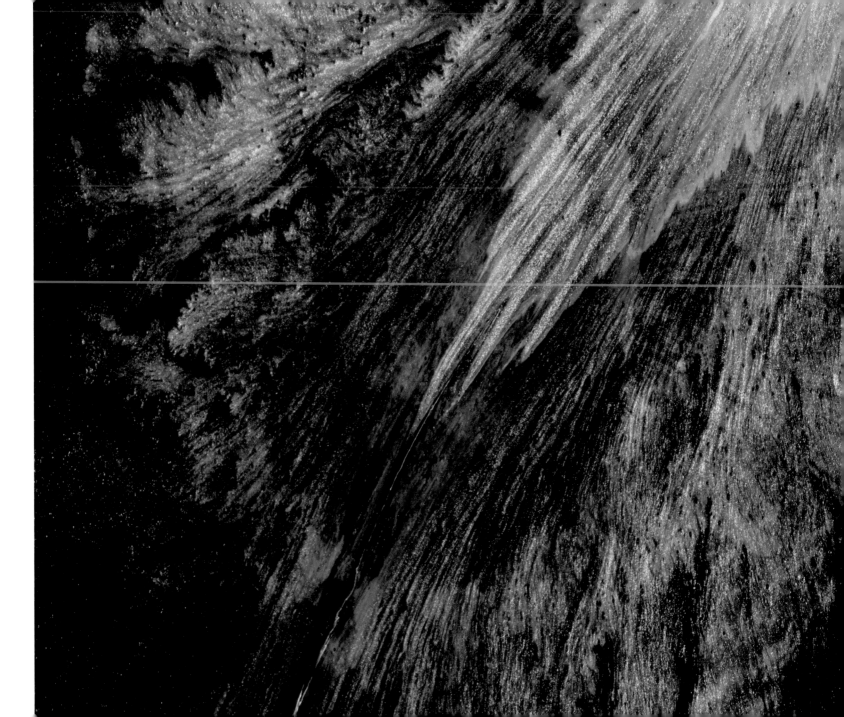

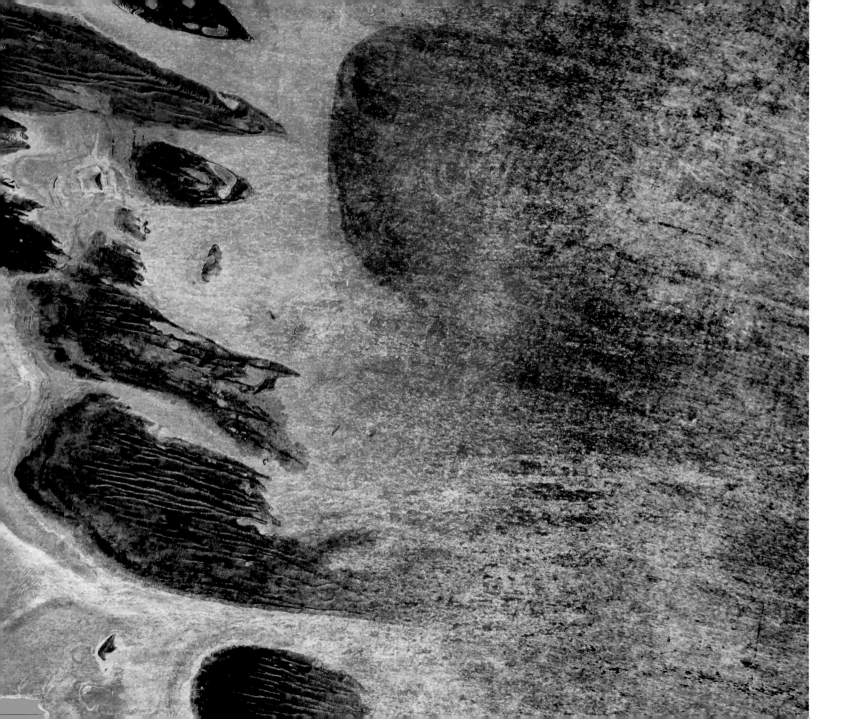

the tides

moon bulges & distends day
after day the oceans wash
ashore and heave
 ssHH sHsHSHH
the shoes shush through the gravel

her face when
the lamp lets out
a mid-winter moon
the dusk of her speaking

glass

the window a great emptiness
behind it blind as a mirror
when no one is home

 & then
 the small
 rooms
 we can
 for a
 moment
 enter

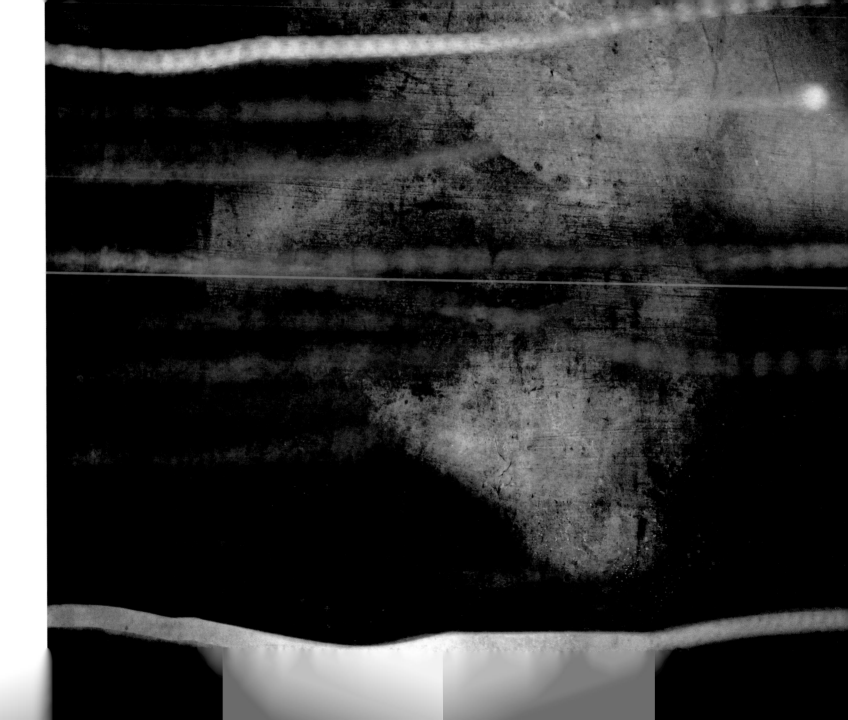

the sun plunges

hot scorpion among sands
a spider whisked
the light rattles apart
the surfaces pitted

 a sudden sickness
we might feel in the mountains
when the world drops
 & the sky slams shut

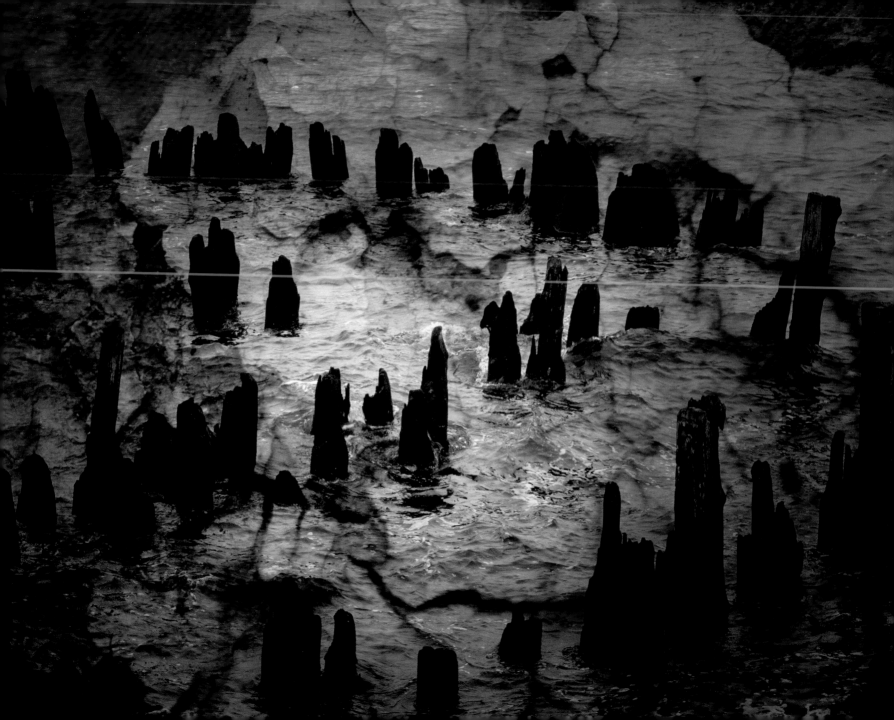

separation

our bodies
at a breathing hole

shadow/
light
/
light

whirl
the weight out
, a thick cream

learn lightness
lean to touch

the world goes
round &
round

/ thin string
that pins us

we are playing
out the ropes
launching into ourselves

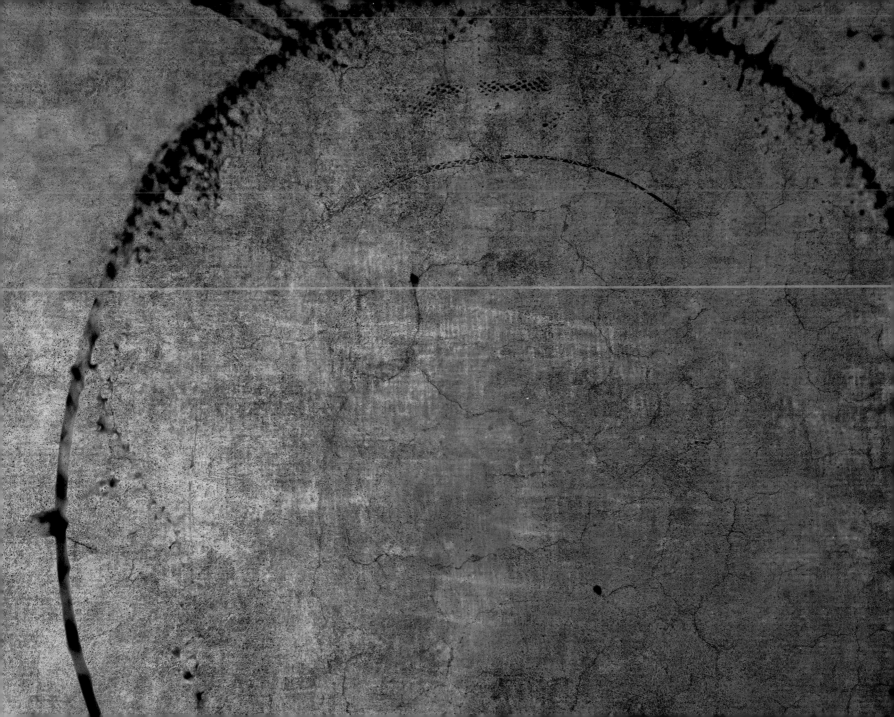

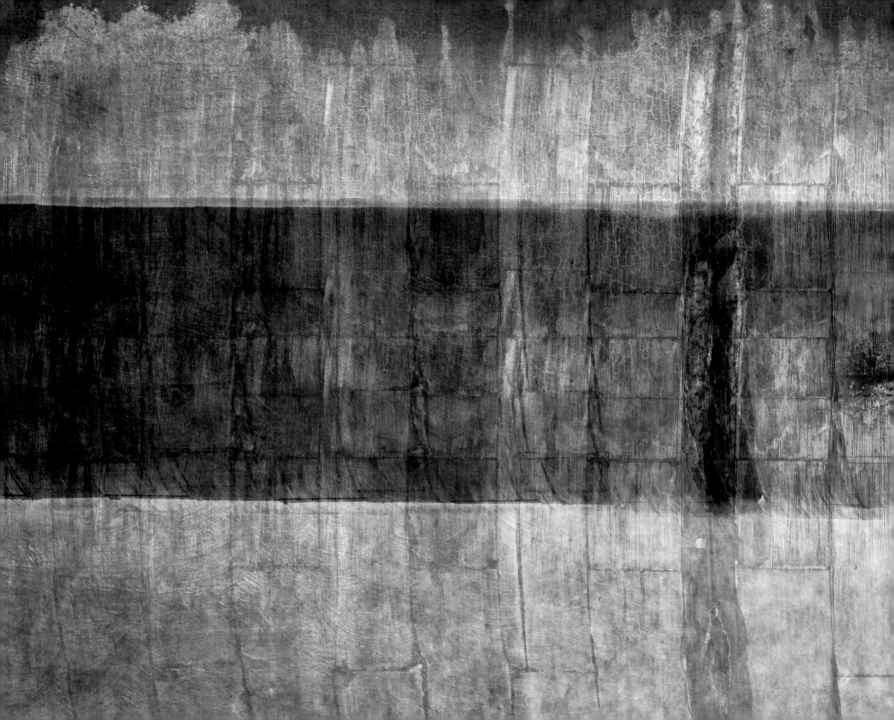

ice age

 it was not a glacier
though there was an enormous weight
that made a depression
and it did fill with ice water
and a moraine

 when he
 closed a gate softly behind
 & the moon turned
 to agate

piscene

all the seas
we swim and swarm

pools of oil & rancid garbage
greasy stains &
rays algae blossom

flesh ripped from living creatures
the hydraulics of life & death

the sea full of poisons

our own bodies
sardines in the seas
thick from sun

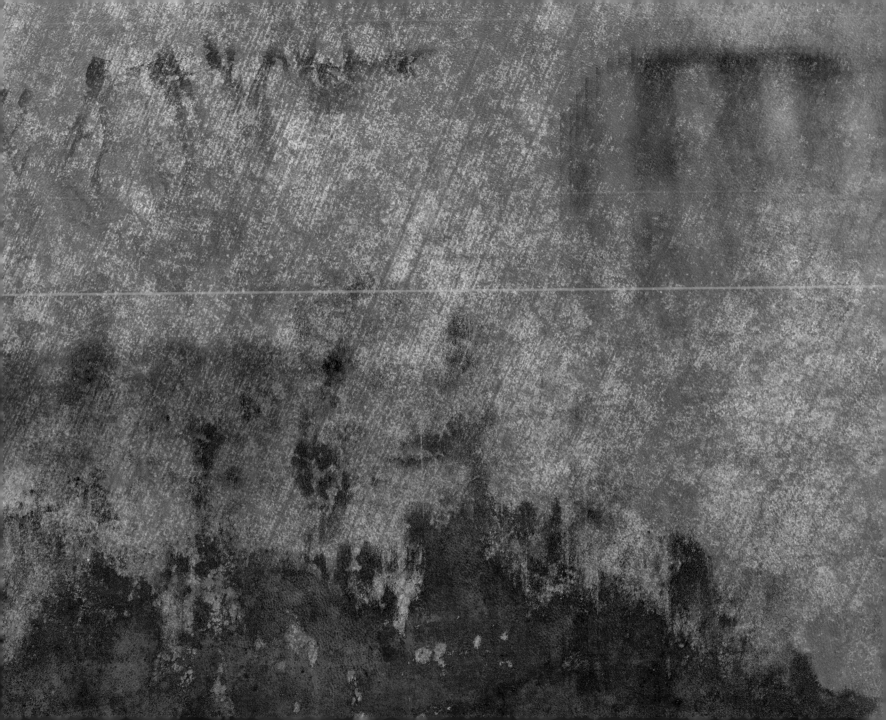

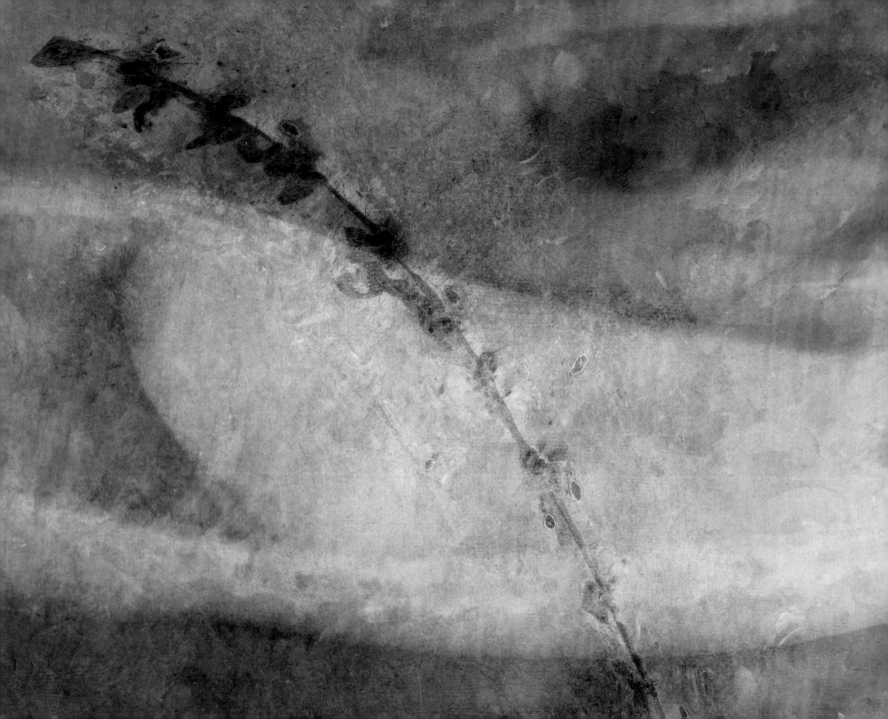

the dance

long reach of the arm
bone in its case
rack of bones

long bones in the arm
long bones in the leg
the tibia the fibula
lift them out of the crate
they've slept their life in
let them out let them scrape
themselves raw
let them

play let them
 fiddle &
bow let them
 dance once
they've left
 the past
they have been
creased or cast in

let them go
 a little
 if only

for a moment
they would enter
in skim and scud

all the bones
jingling the flesh

the bones jingling
the leg bones
keeping time hip
bones too the ulna
the radius circle
carrying you through

 tip, step
 do not
 stop

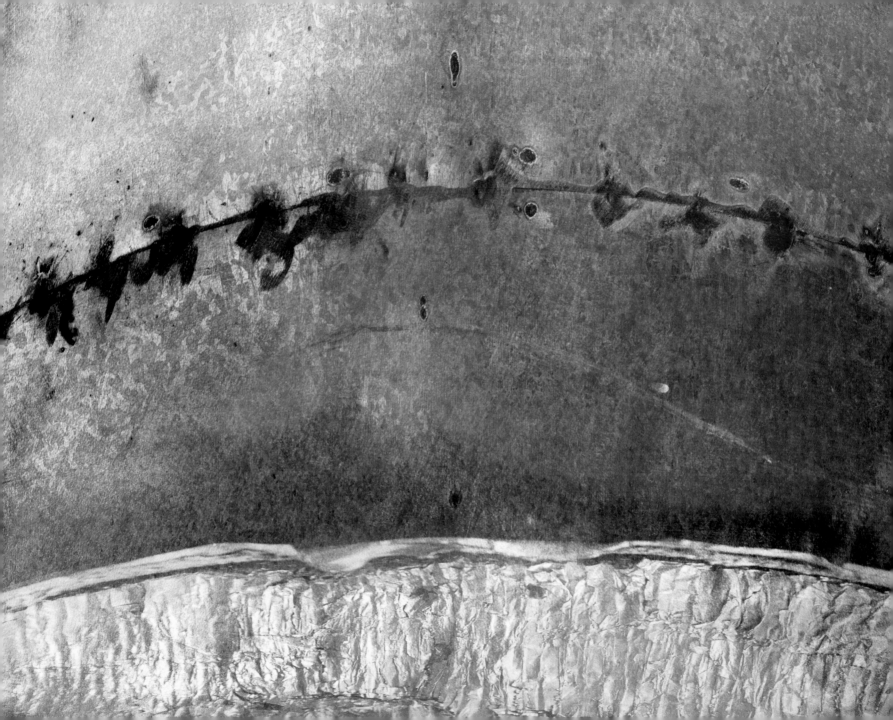

streets at night

a stem of light
blooms inside darkness

the way it is with things
that fall out of the sky
the moon & sun inside

tail lights sucked
into the street
a red gash on the night

it goes too fast

w?hat ¿what does
when s/he said
one of them said

the earth
 \that old cabbage
that cold bastard
takes us for a ride

 until it spins
 the light off

every night darkness
rises in the big bowl
soft and yeasty
and then it is night

 yes he said
 i guess we could

 i guess it does
 i suppose it might
 throw us off

 it goes so fast
 so darkly

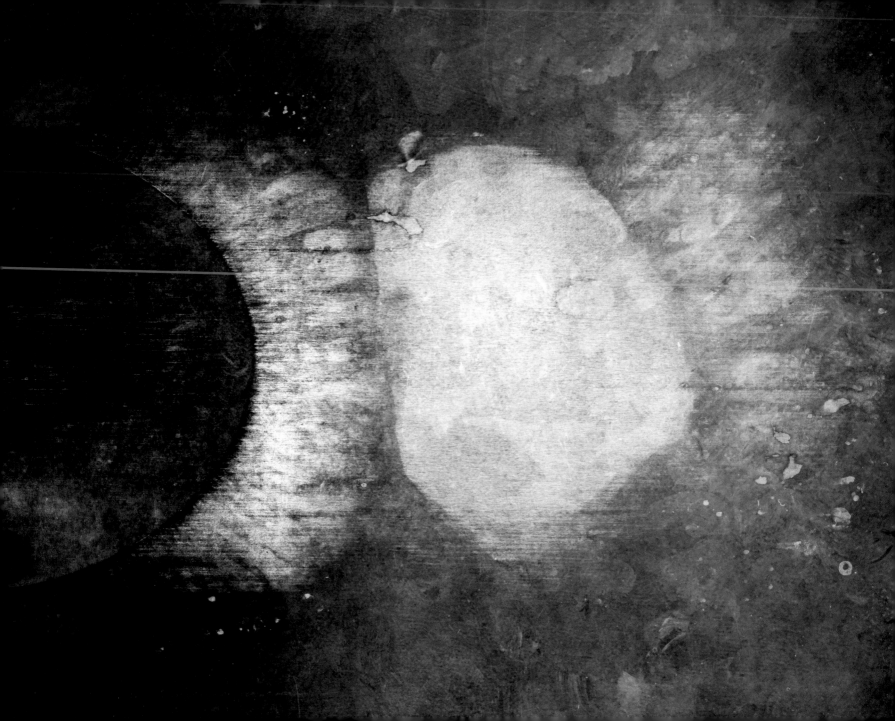

seamstress

the pen is a pin she pushes
into the comfort of darkness

begins to darn the ink to couch her words in
pricks and teasings and later irons
the wrinkles of his confusion

she is taking measures to stitch earth and sky
which every evening tugs and threatens
to tear away in a stiff wind

she has been pulling
the thick thread of horizon
through the eye of the sun
and she tugs it up tight as a gromet

the robbins run & cock their eyes
loop buttons in and out
do their level best to
wrap the words in their red attention
peg down the high blue sky

they repair the day all grass long
pull the camomile in
and out of the driveway

the intricate embroidery
as if in reverie
with which they hope to
fasten things into place

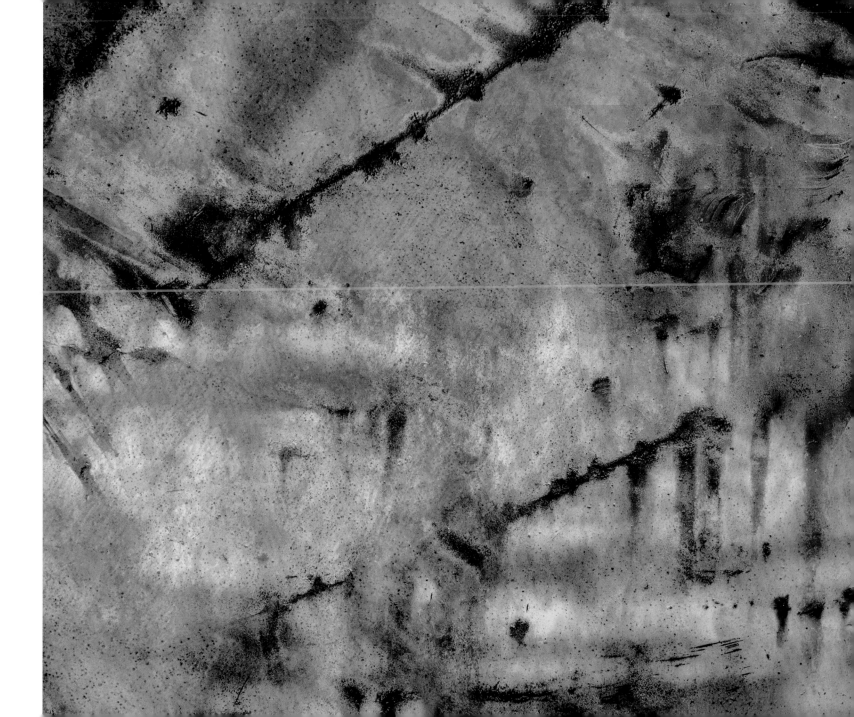

east of eden

 saw its blueness
 come out of the earth itself
 bluing in laundry, that fresh

 earth an opal they could wear
 a finger on the birthstone

 the blue eye, once a light house
 fuzzy now as the flannel we sleep in
 something in its eye, weeps for our harm

 earth a blue iris is filming over
 ships a tear in its eye
 starting to go blind

 we do not want to be homeless
 exiles from the garden

 want to turn season to season
 watch the fish and the birds
 feeding on stars

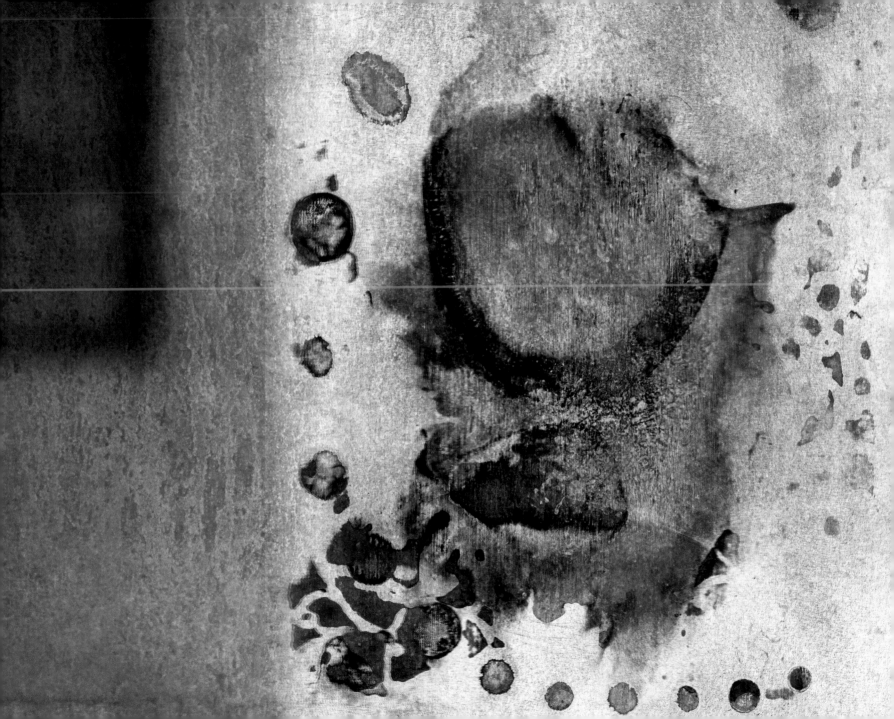

bone house

inside which we pull
neither ghost nor spirit
 casting nets

 which tear until
 the sun leaks marrow
 tomorrow & to

 morrow time borrows
 the hall warps the mirrors
 before which we move
 as if we were spirits
 in split in finitives

your sorrow, bidden,
quickens, your ankles,
once bitten, click,
like beads, in prayer

castanets in the morning when you run
into a nest of yellow wild as yarrow
pests cannot kill nor drought put an end to

you want to live as shadows shed

 as a sparrow
 fishing for light
 as near and narrow

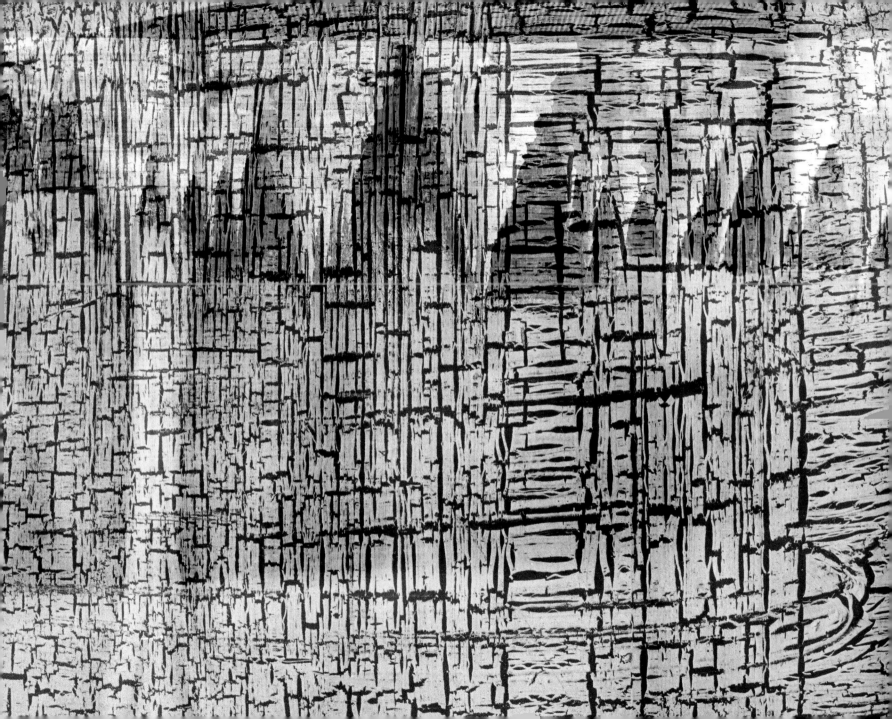

to make the stone

"Poetry lifts the veil from the hidden beauty of the world,
and makes familiar objects be as if they were not familiar."
–Percy Bysshe Shelley

when you spin
it from your fingers and it
skips on the water
clatters across ice
also in your head

a small stone that may bruise
which could be
more than an octopus
perforated from knowing

your heart if you wished
could be an erratic from the last ice age

the cattle rub loving its hardness
its perfect scuff

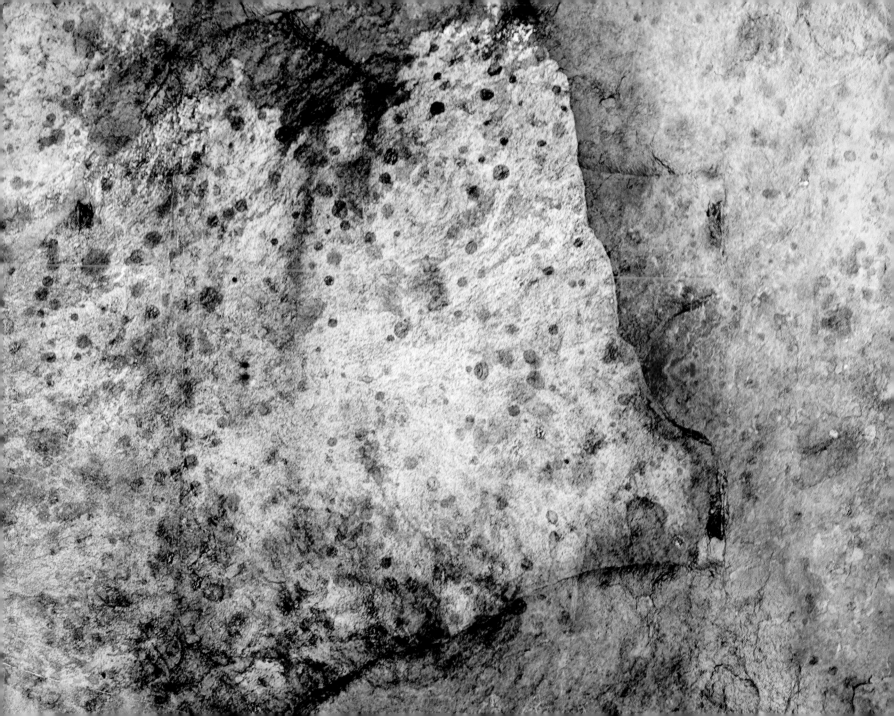

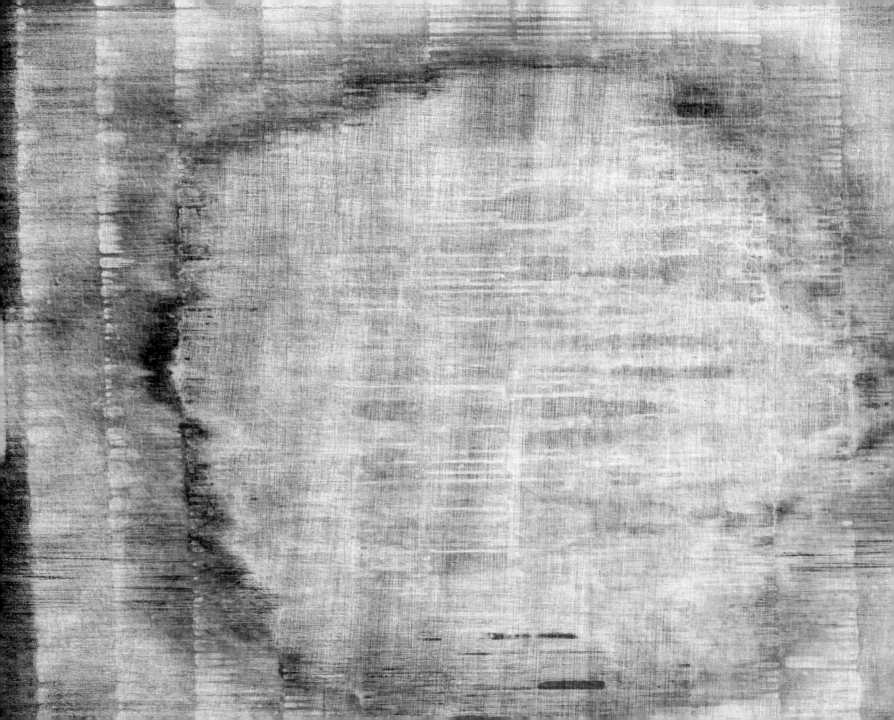

gift

how beautiful
 you wear
 round your neck

swift vermilion of your devotion
 soft token of your love

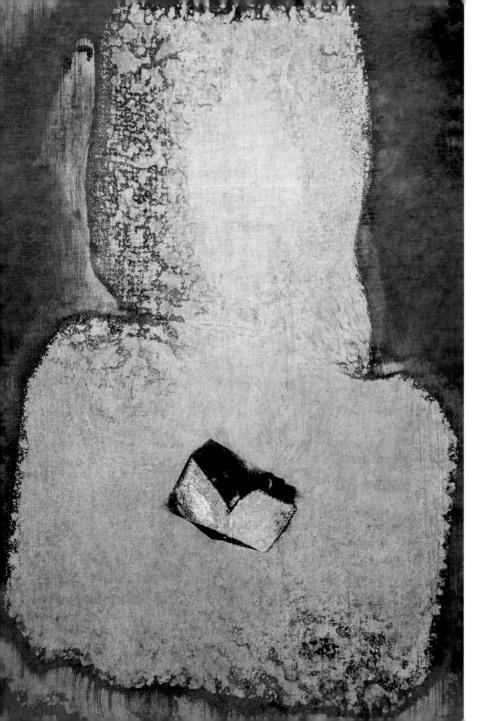

seeing ghosts

some see ghosts
streaks of people and sometimes
gummy clouds with unspellable names

some see a marble they hold up
to a maybe eye where the light melts through

perhaps they do and perhaps you are
thin as cigarette paper and as chique
it may be you are a pin
and having left the paper
can float on water
bright as perfume

the world you perform
looks gray and strained
though you yourself
on the other side may be
bright as stained glass
a jar of orange marmalade
red berries and a spoon we cannot see

a sweetness you would ladle
a cure for every hurt or malady

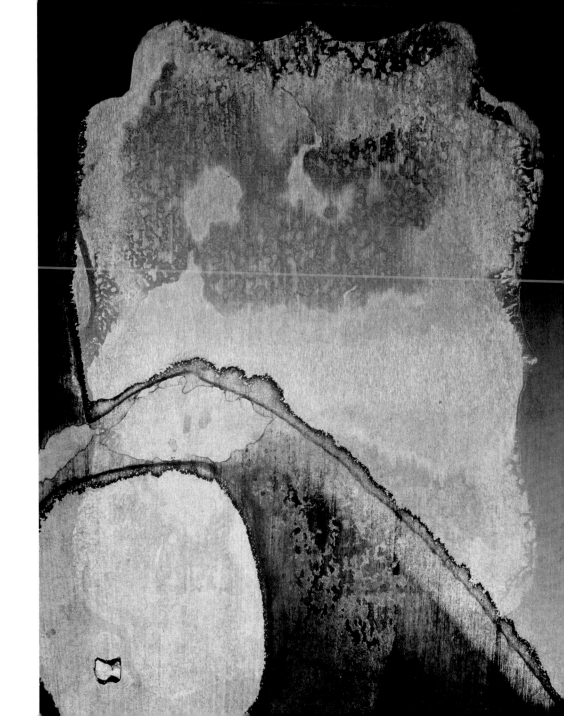

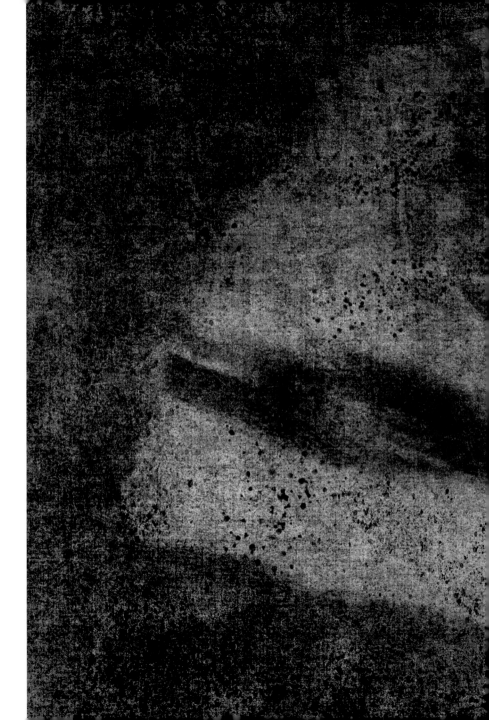

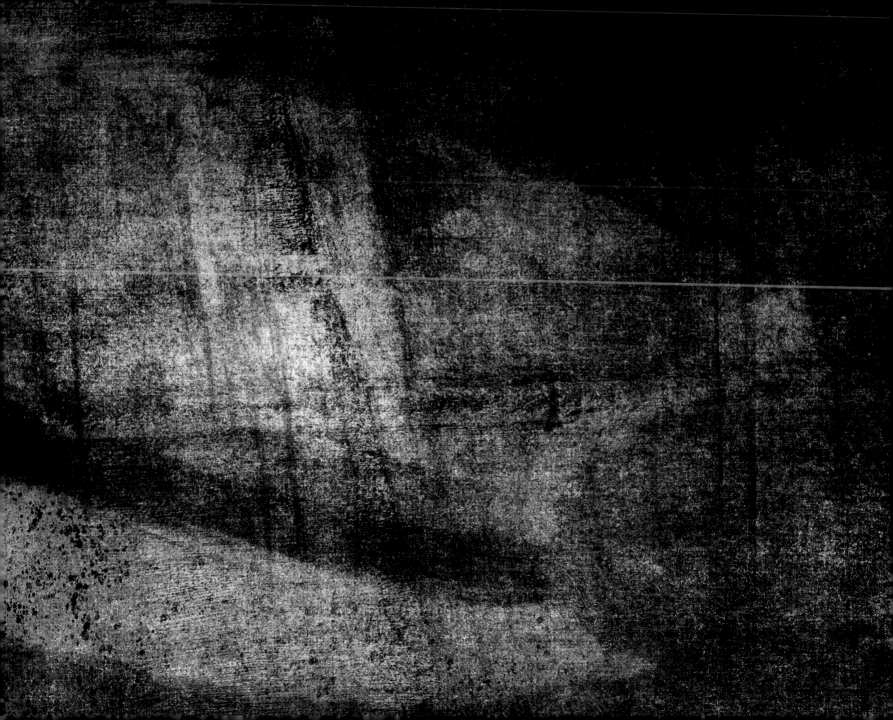

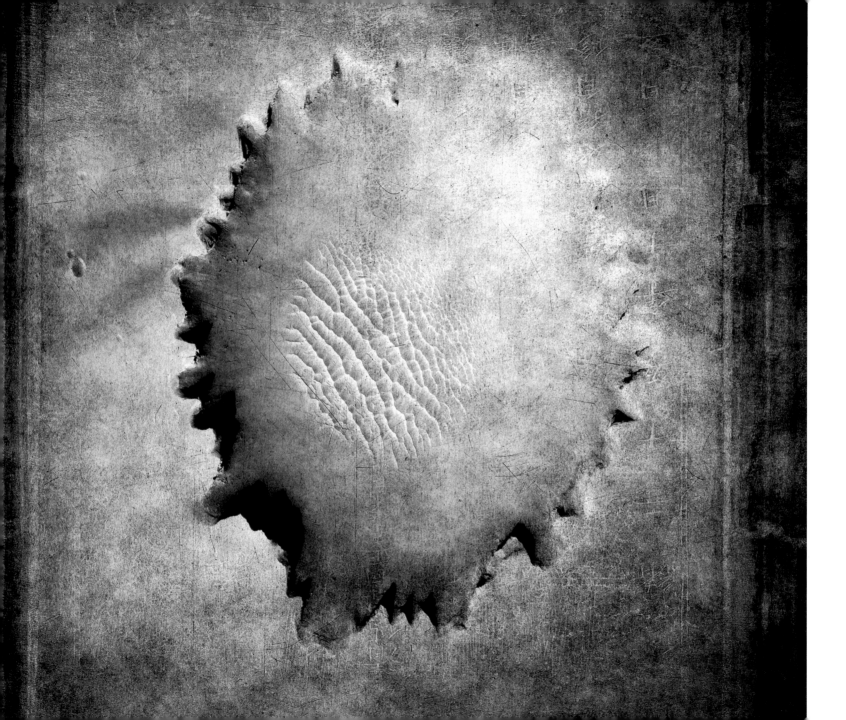

fish in dark waters

strange stars blown across stars
storm the thin cold waters
the constellations fall out in silence
from stories we always told ourselves
found comfort in, felt at home among

swim in a new phosphorescence
leashed to a wind the sun blows out
 : fish in dark winters
Pluto in his dark root cellar
never imagined never thought to keep

supplements

 know also we are
sticklers for detail even the smallest
minerals iron cobalt potassium molybdenum
manganese vanadium zinc slick enough
to keep from sickness tick long
enough to keep all creatures going

 splash in what is left of
 the warm puddles in our heart

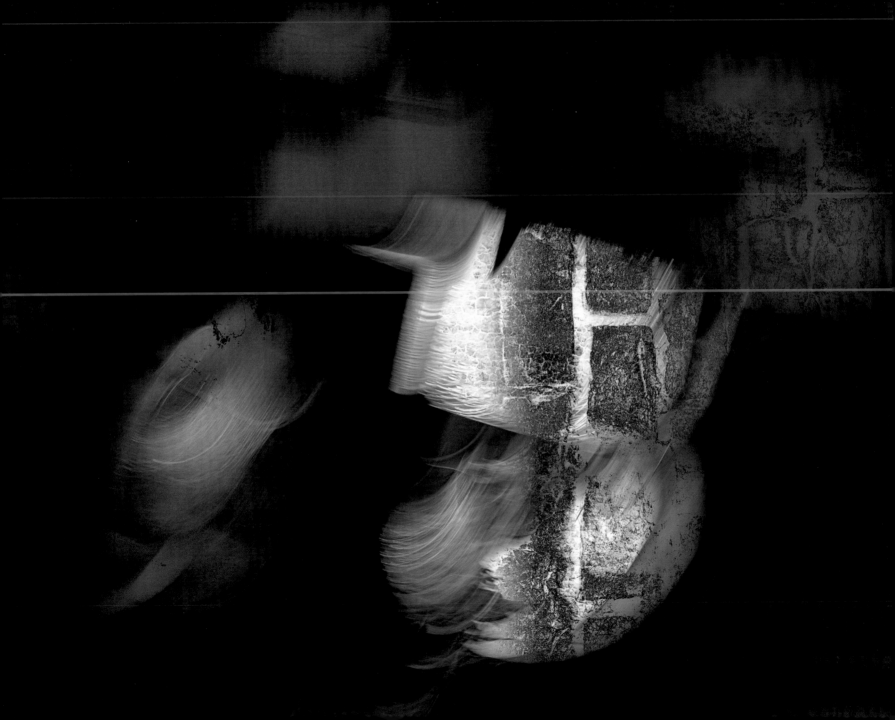

orchard

when the moon is
burnt to charcoal
the trees blush
with rouge and lipstick
turn bright as cranberry
brighten in apricot and pear and plum
peach gloss and satin

their perfume rises
on a mascara night

apples, raspberries, cherries,
juices from a windy press
we cherish and suck down

our voices rising
soft as plums
warm as rum
in the lilac air

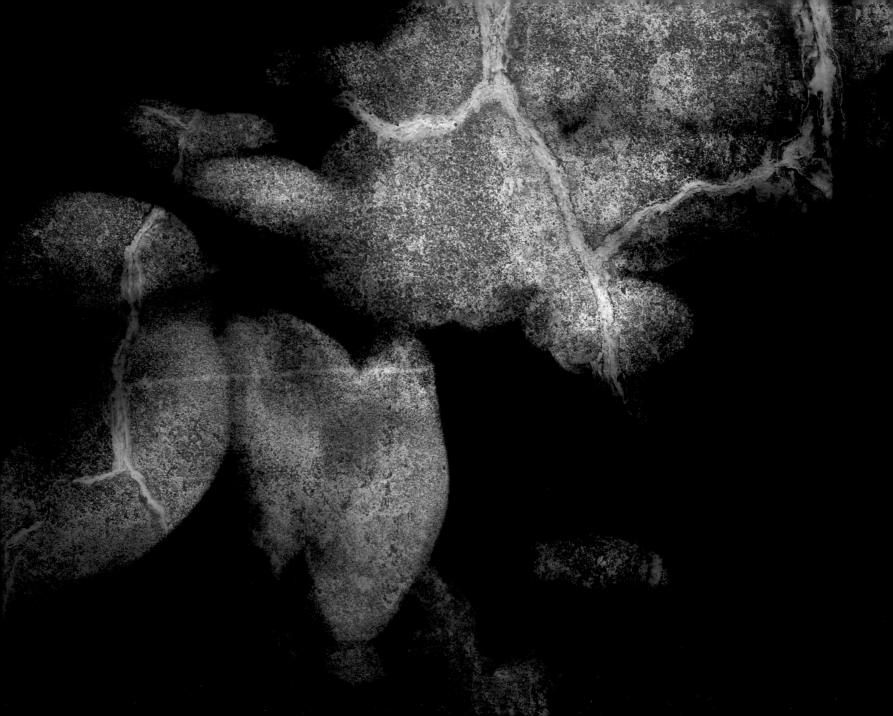

night

blooms, a small crocus of light
 holds our eyes
and i wonder in the night have i
penned him in the diary i keep brown
as the plants have grown in my garden
pinned to my thoughts each night
before i sleep

 & the planets
 spin & glimmer

witching

dipping
 a wand
 in the dark
 & we

 flicker
a lantern wick

 /lit
 till our bodies
 leftover rain
 into the night slip
 & dreams
 swallow us

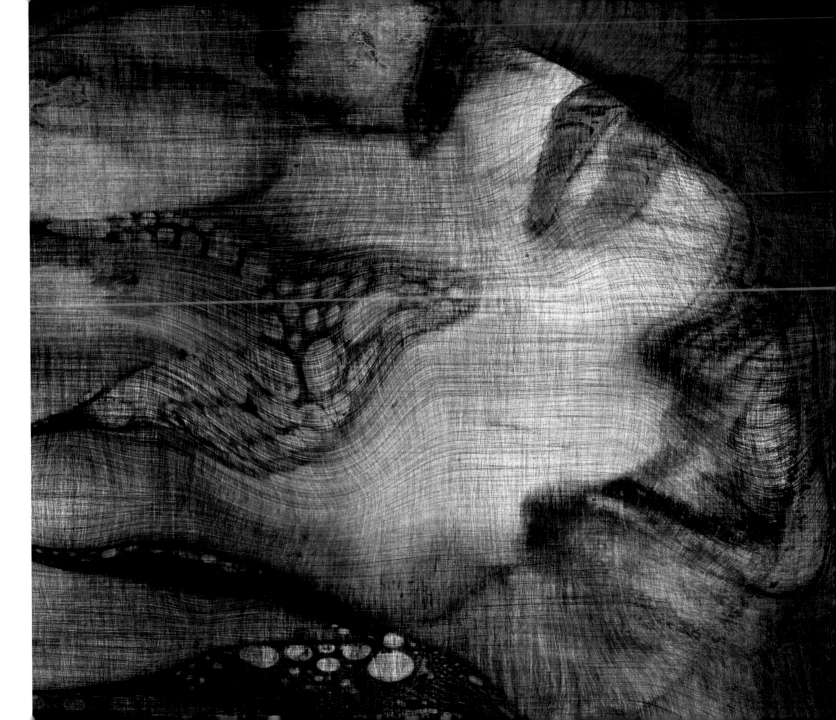

breathing

when the planets shone
the cold would eat the pane enact
the exact beginning of the world

eewww oohhh
they would say
wwhhhhwhwhwh
something blew in their ears
and they would press
their lips close until
they felt the damp

worked to enlarge
an oval of carbon dioxide
the shapes of their small lives
pushing against the forests
until they shoved the morning up

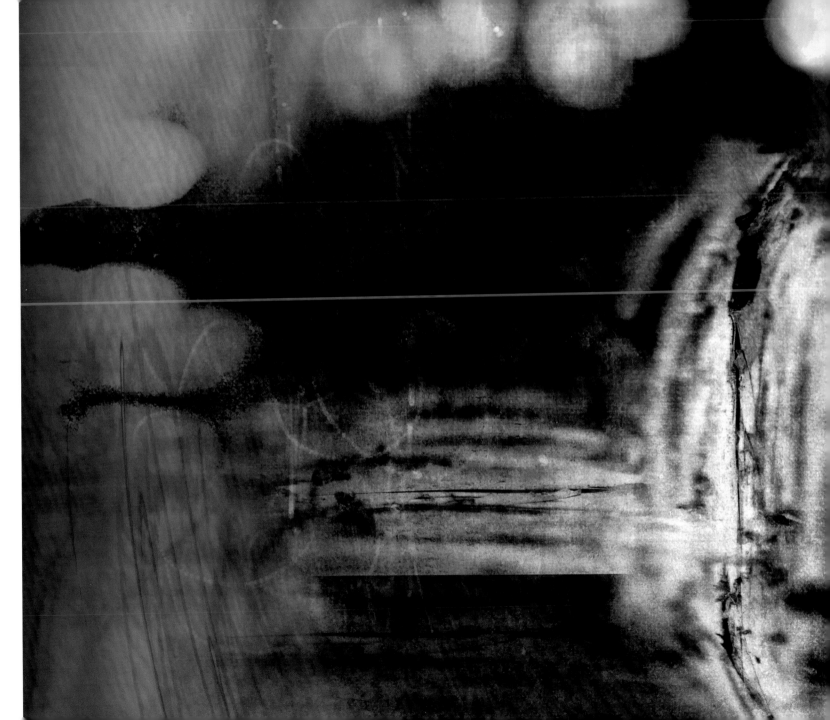

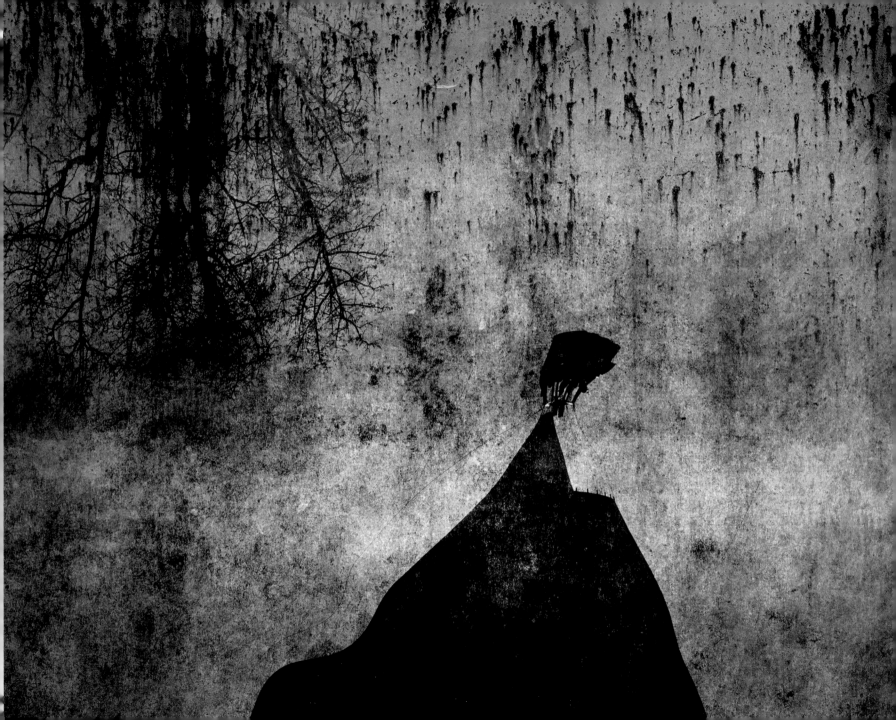

a friend in london

all night he sleeps on his side
right arm bent
at the elbow stuck
straight up pointing
indelicately it seems
to a hole in the ceiling
angels might have fallen through

has he raised his hand
is he asking
to leave the room
does he seek permission to fall
asleep all night reaching
from the dark waters

every morning he stretches
a sleeping finger to a god
he knows is not there

to shine in the dark

the drawers gone brown and musty
a room where we have stuck
on the ledges hung out
our fears on strings to dry

 missing you they say can't
 stop thinking of
 all the what-ifs
 \ if-onlys

 the sliver of all hopes
 dipped in oil waiting
 to shine in the dark
 deny the day's appointments

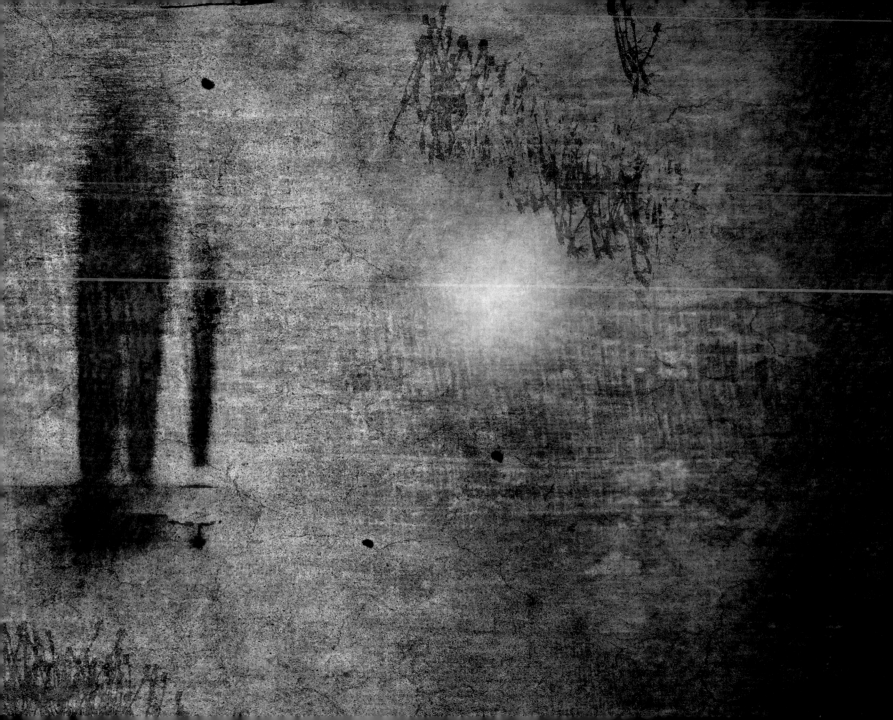

the hot wind from inside

brain a bulge of helium
bright from rivers dreaming
in head lights brightens
passes in a red stream

weather balloons
that tilt & shine
a dominion observatory balloon
catches the wind and
crashes in stubble late one fall
in sparks of frost

a Japanese city a white stem
a head of cauliflower
a tumour spreading on itself

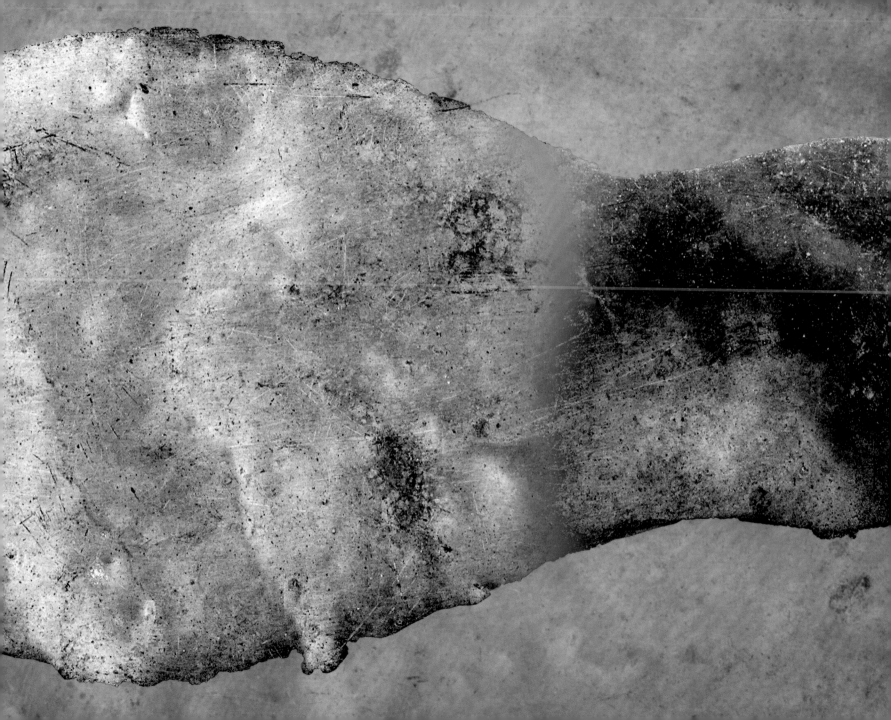

high opera

 that was another
night with other sounds
lights that turned suddenly
like carriages in the streets
& loud as cartridges exploded

ours a devotion to recitals
lifted from the score
the smell of first stars
that fizzle like lime
corners carboned with darkness
and always the loud carom of atoms
bent in purple and crimson

the rituals we love
the drums and cannons
going off in our hearts

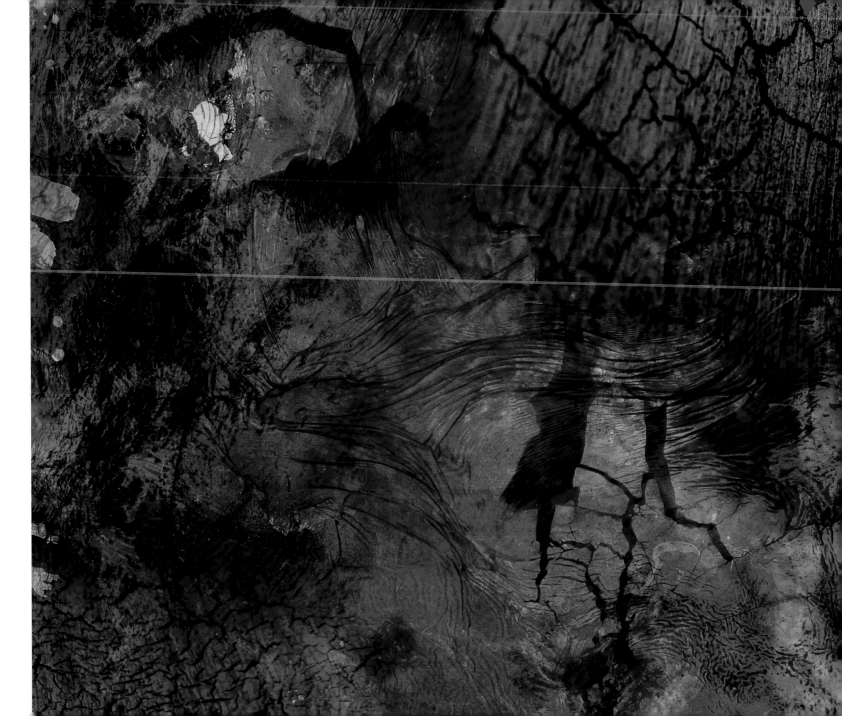

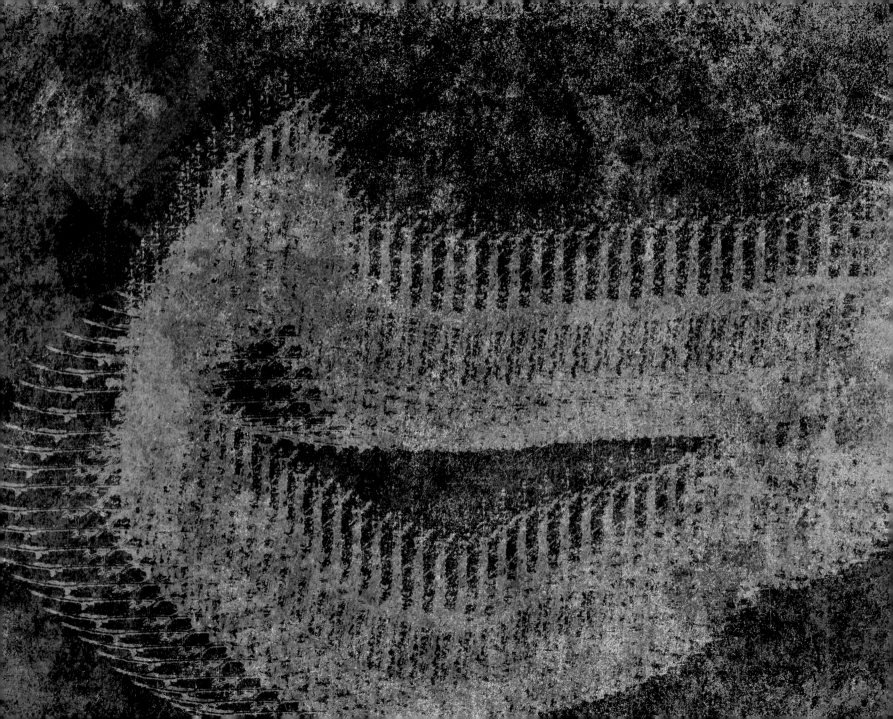

silence

why then
 if the moon is

a thin wafer
a lozenge

 why then
 these threads

 my throat
 tied shut
 with wet
needles & threads

reading the sign

days we drown
spatter confetti
until it is snowing light

spray graffiti on the train
inside darkness /whose tunnels
glow with the writing on the wall

could be rock
-island hens /waiting for rain
blowing in your face
the whole sheet speckled

nobody to tell you there's no point
scratching the dirt
the sky in flashes of lightning

sewing hot sequins on your blouse

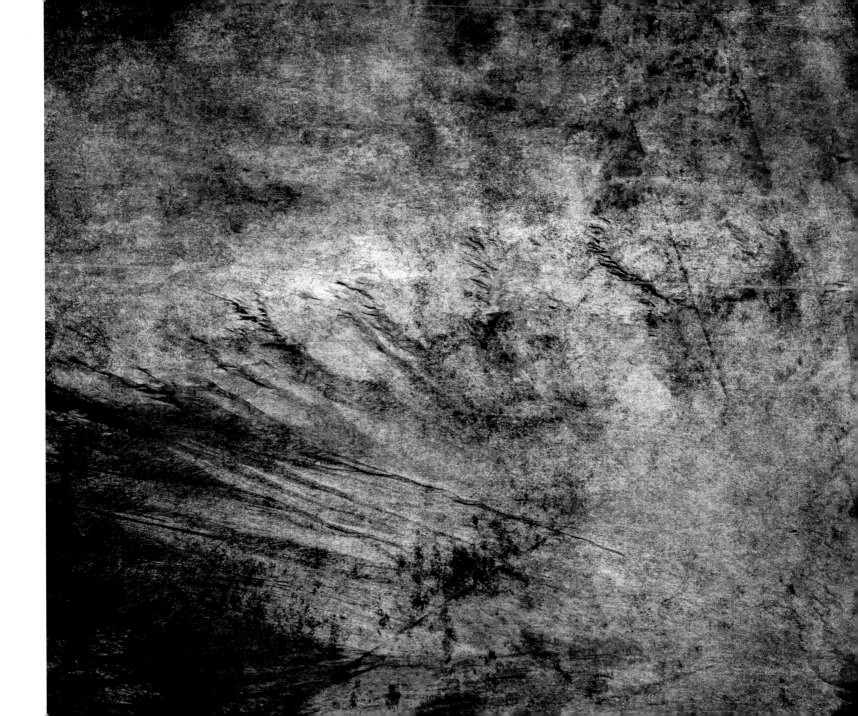

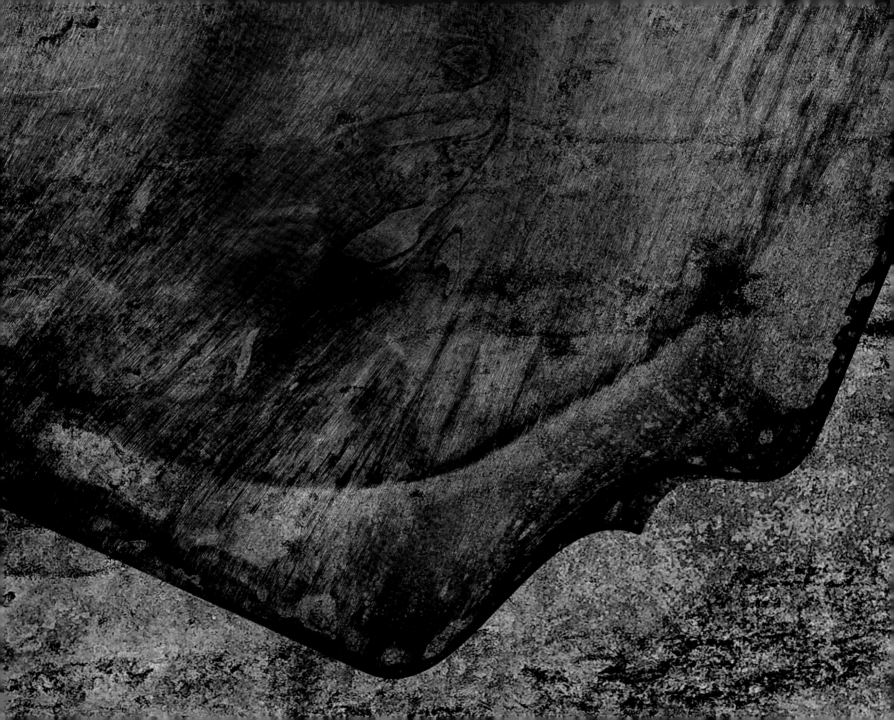

night horses

 horses out there
 grazing on darkness
 night a pasture
 they dream in, standing

& when they dream
do they dream of running
past the wind running
through an electric sun
night jingling from their halters
 do they gauge
 sugar in wind
 gazing at the blue frogs
 their dark eyes gouged out

 El Greco lying still
 & stiff as forever
 strange grin on his face
 ants cleaning his teeth for eternity

 nights I lie naked
 grass the sky full
 eyes staring down
 open as stars, as uncaring

 & days i fold
 a sadness into
 as i do your clothes
 when i hold them

& the wire on the fence
sags from the weight of sun

gibbous moon

it is love binds us to the hump-backed
moon when it sprays and blinds us

to its constant straying
who tiring of our romance

is sliding away 1½ in
in a year and a day one day will
roll off like a lumpy rock and abandon us

its days flighty and impecunious
a penumbra in what of you i remember

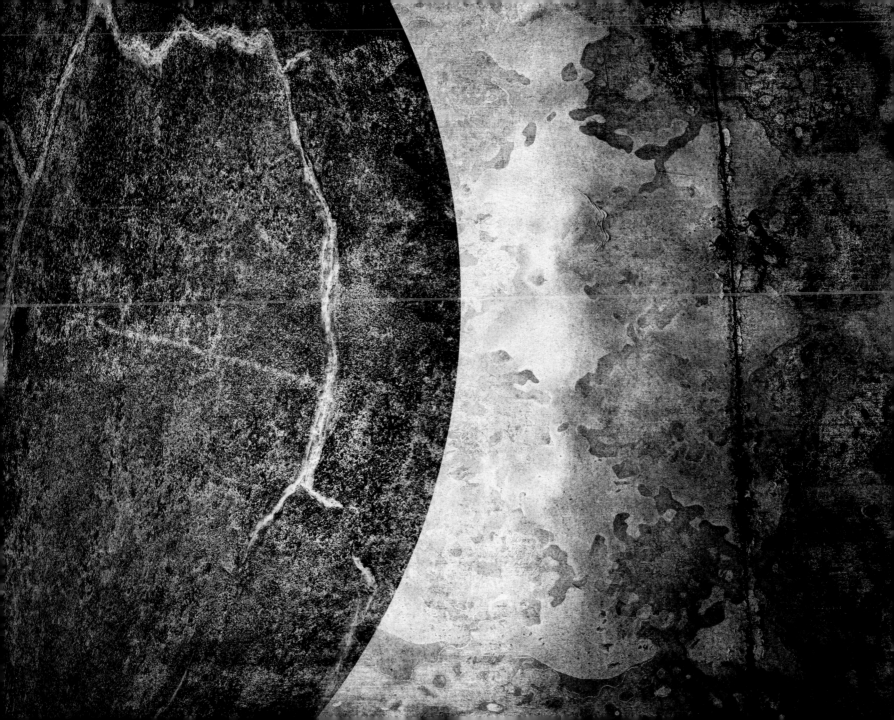

the colour of your dreams

the gray wool blanket
you draw every night
around your shoulders
and what you might say
all the way up to your eyebrows

yet you grow restive
awakened by the terrible yearnings
that walk the sidewalks of your dreams

in stagey dispersals you
must have known
were only rehearsals

you spend the night wishing to be
profligate with words
rubbing your eyes that smart
from never saying

 lie awake
 eyes wide open
 talking in tongues
 angels lying next to you
 speaking wetly in your ear
 small streaks & spatters of blood
 flashing with crimson desire

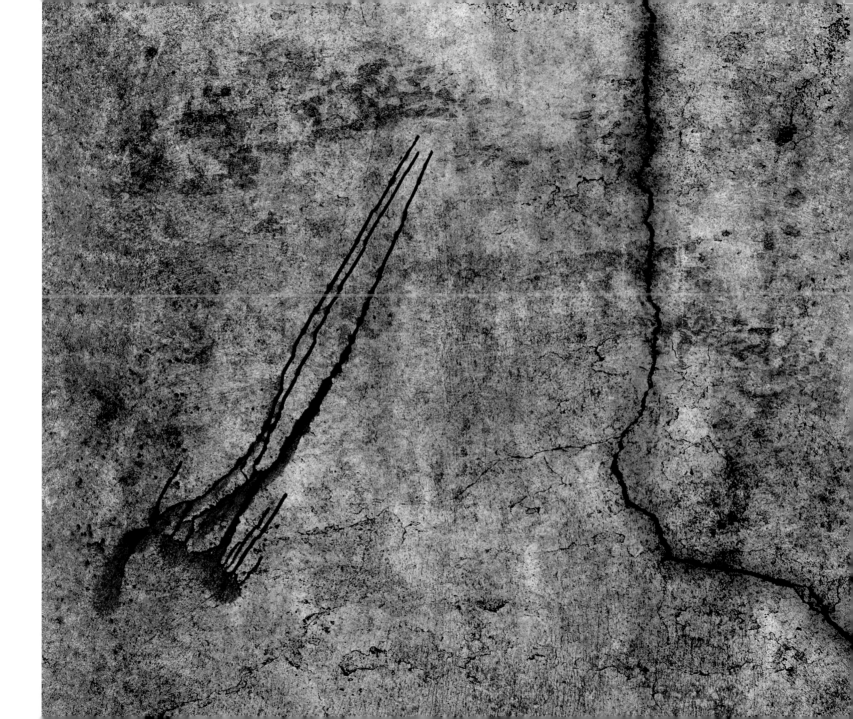

excerpt

a failed and melancholy gardener
stiff-kneed, square-shouldered,
left to scratch where the earth
in a skitter of dust
has come unshelved

 would be blowing creatures to life
 in ochre iron oxide charcoal
 brightening the wall in Lascaux
 the cave in Altamaria,
 found by children, by chance,
 red that glows from the stone
 intense yellow black minerals
 leap in brush and swab and blot

 the walls ringing with
 colour and contour
 that leap into the world
 a grace mid-step
 upon and around the rock

except the human traffic
has breathed heat & humidity
contaminants that dissolve
animals, humans, that
catch your breath, dots,
lines, sticks, rectangles fading

except the wind in grit scours
and light sand-blasts the days
the clay cracked and crazed
the cement about to cave in
the colour draining

 nothing left but
dribbling seeds against the heat
hoping to tinge a gray and desiccated earth
or bless it with our spit

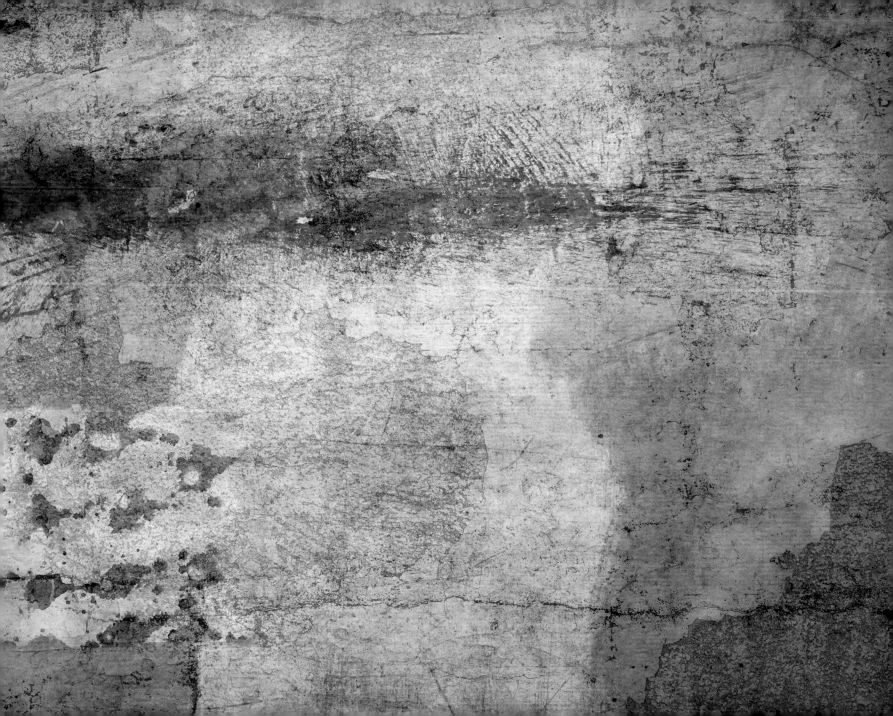

heart when you play it

wires so tiny a person
can hardly see
or bear to hear it
clink in the breeze

the all-alone sound
tin can whenever you speak
or are spoken

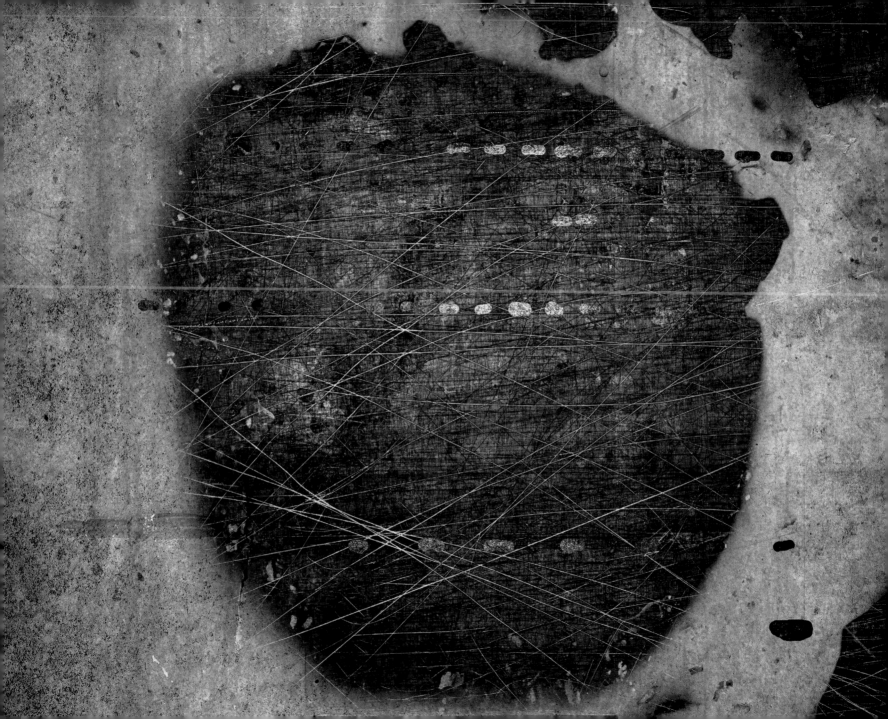

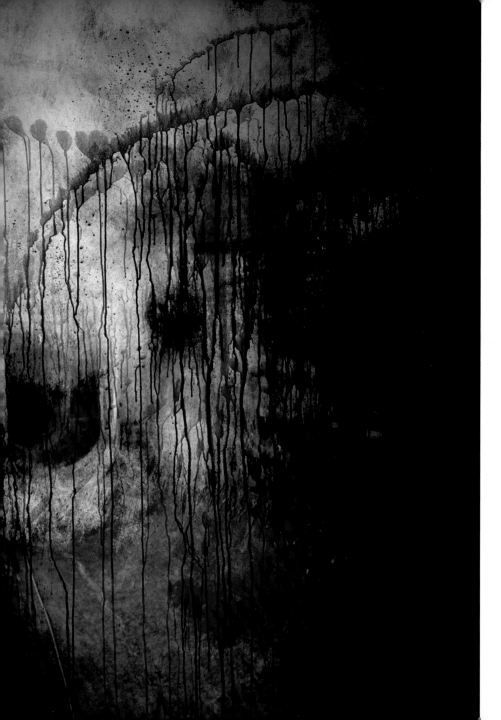

their sudden screams

across the windy spaces in their hearts

 a knowing so swift
 their eyes must be turned
 to the end of the world
a sky from everlasting to everlasting

 the blood from ruptured veins
 streaks down their faces
 always the same
 always forever

all the people who fall
into a hole and away into silence

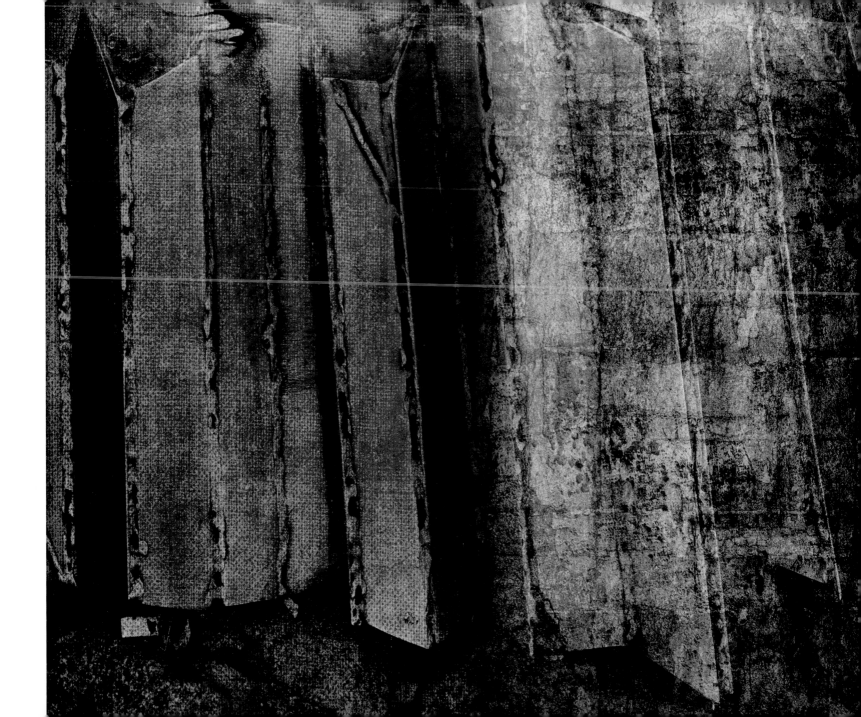

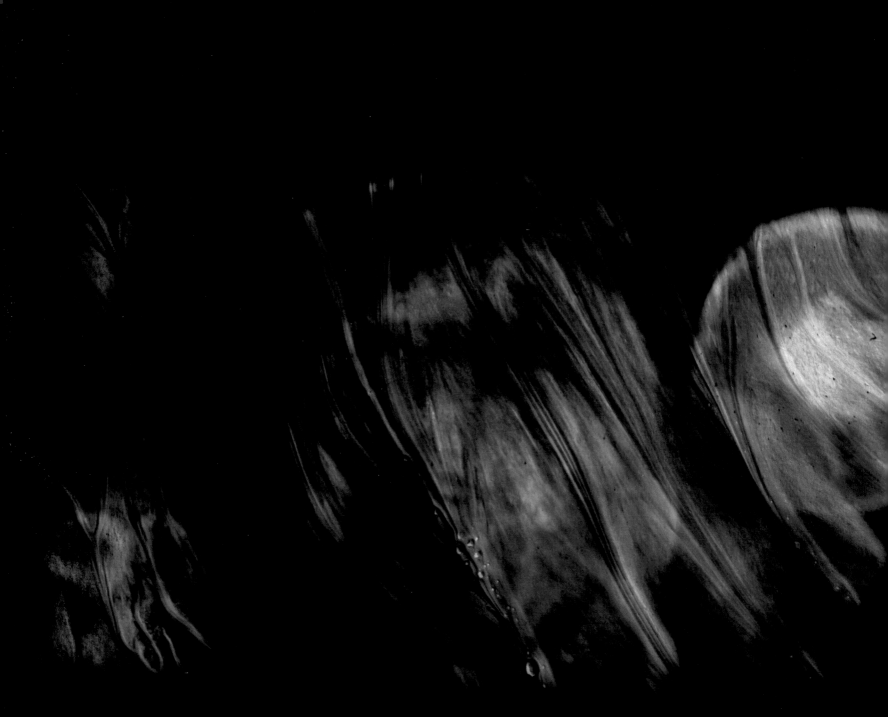

ghosts

dear god even the light
seems wounded when
the big birds blow past
their thick braids the sky bare
spring so clean it seems
nothing will ever fray
nothing jerk free

birds breathe with the shadows
lengthening and then short
the trees have netted
 thick glossy days
the winds inhale every fall
 summer throws back

 speckled fish
the bright air
 , swimming

warm as memory swarming
 shriek & mutter
 all shadow long
 a hard breathing

, caught, singing,
along the wires

every morning ghosts
along the morning
eating the bright air

summonings

our lungs to keep
the sky from falling
your breath into mine

and shore the air
the short words
we are unable to shout
whatever coarse or cross
words cross beams
whatever timbre

we should speak
against the wind

the dirt that threatens
to fill us in

to turn us in
to abandoned wells

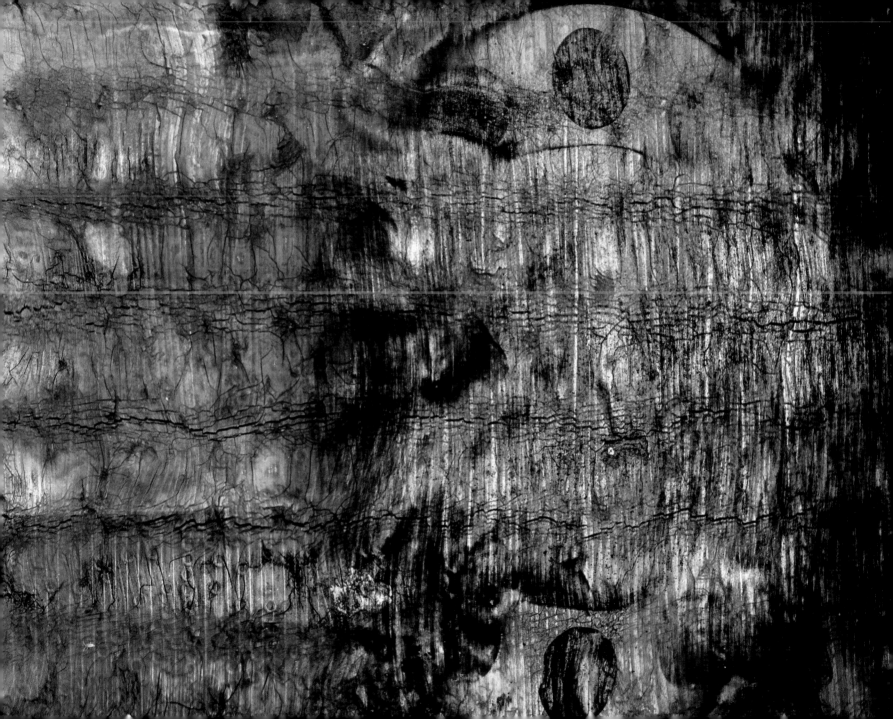

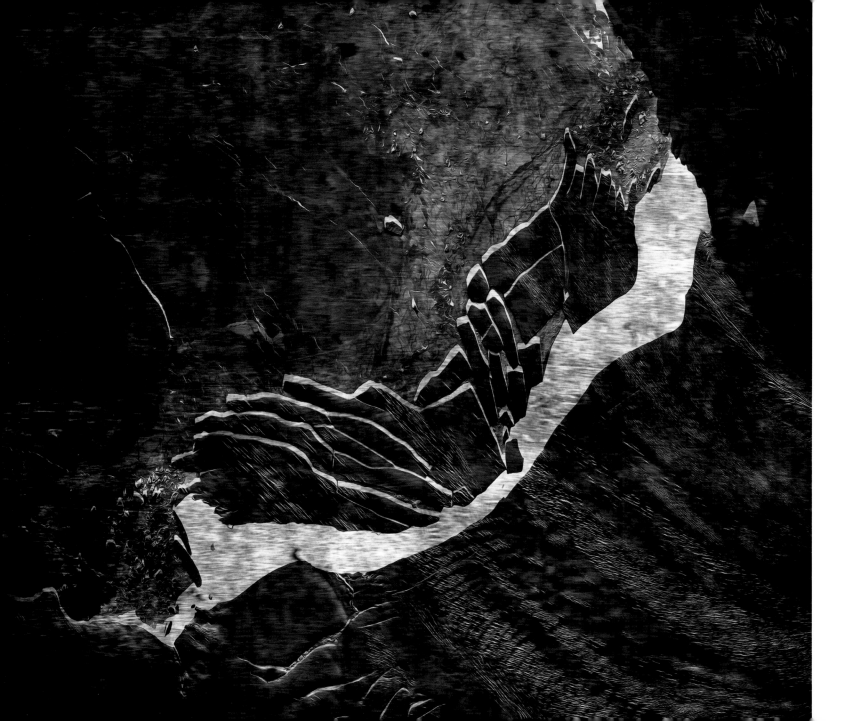

prairie thunderstom

in the dream we
 heard it
 at the edge of the garden

 crr-aACKK
 the gash in the air
 a stomach ripped open & the

 sudden crush of rain
 cold so cold
 no one could
 breathe

 water pouring into the cracks
 \

 a room of ice
 & a dead robin

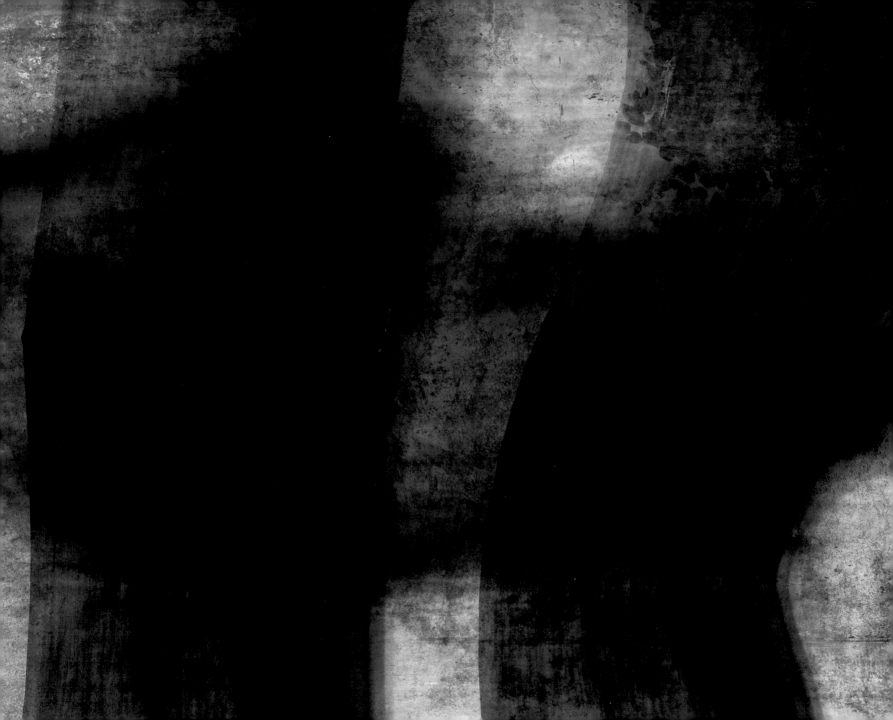

february

i.

7:45 Feb 2
 chill of glass

 : moon
a finger nail
a contact lens
stained with protein
lists to one side and
studies the sun

wobbly and luminous
as a lemon
serious as a nun

 /scrapes frost
off the window

ii.

10:02 Feb 11

bird on the branches
the pine tries to shake out

 10:25
 gone
 behind the spruce
 wet with light
1:37
 bird at the glass
 flutters the ash
 branches the light
 trembles the table
 the bench

bird bends
 across the wall
 across the shadows
a warm weight on the hand
 the long arcs & oblongs
 softness on the paper
 stillness of the cat

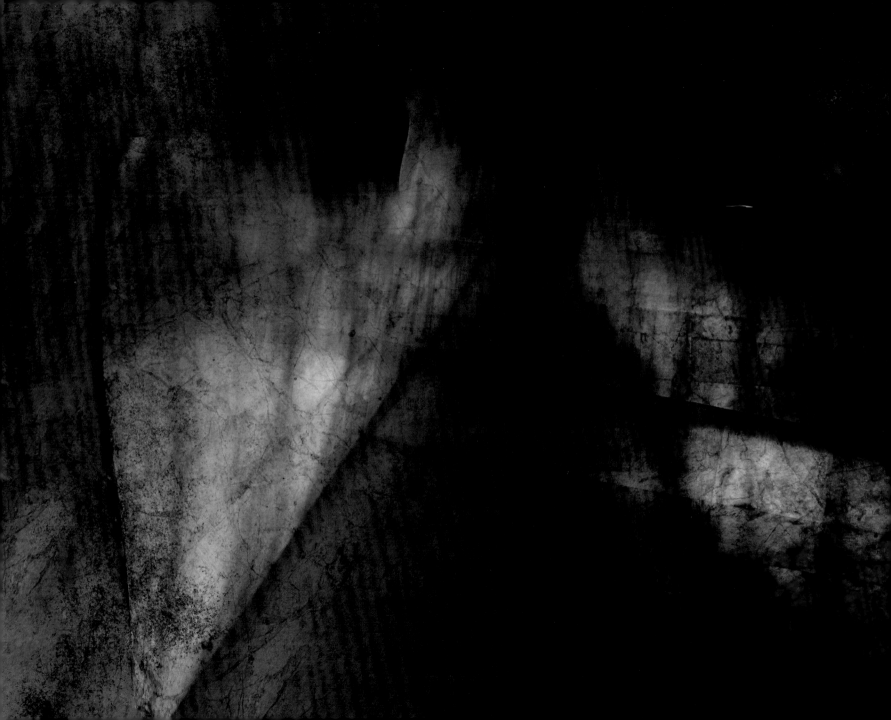

comfort

you must not think

you are on the dark side of darkness

you must not think
it is not
a little
lonely there

at the window

(for Ivan Eyre)

on the edge
/there
/just beyond
a ledge past which
we find the debris
in the shapes he has nearly discarded

a strangely windless world
comes & goes

years & years at the window
practising what it is to see
knub & purple
bramble & red
to study the world until it is
twiggy & dark

sometimes it is snow & ice
keeps him in season drawing

thoughts that lie in weight
between the brush and his hand

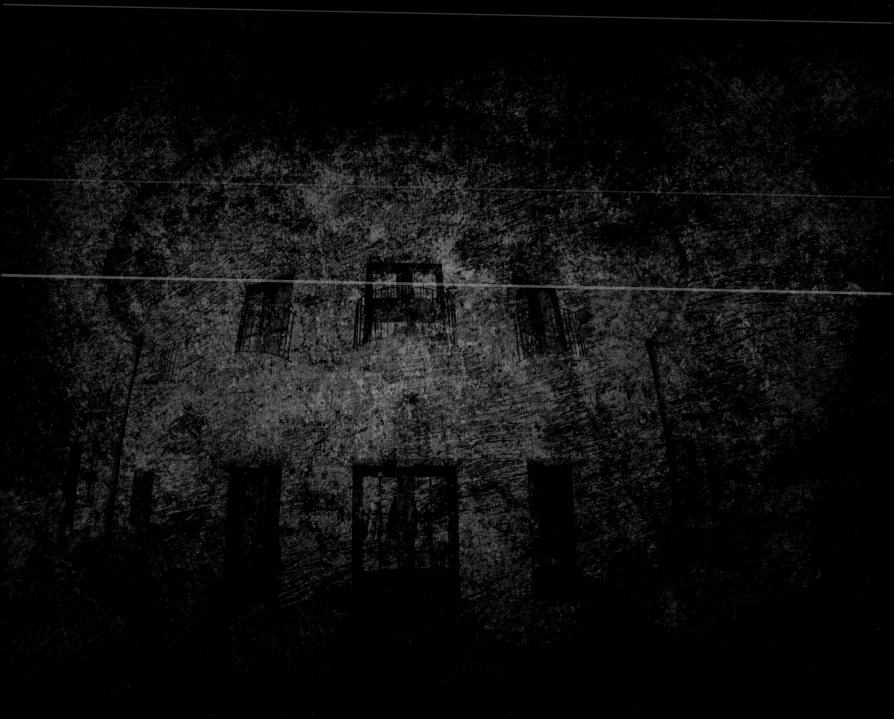

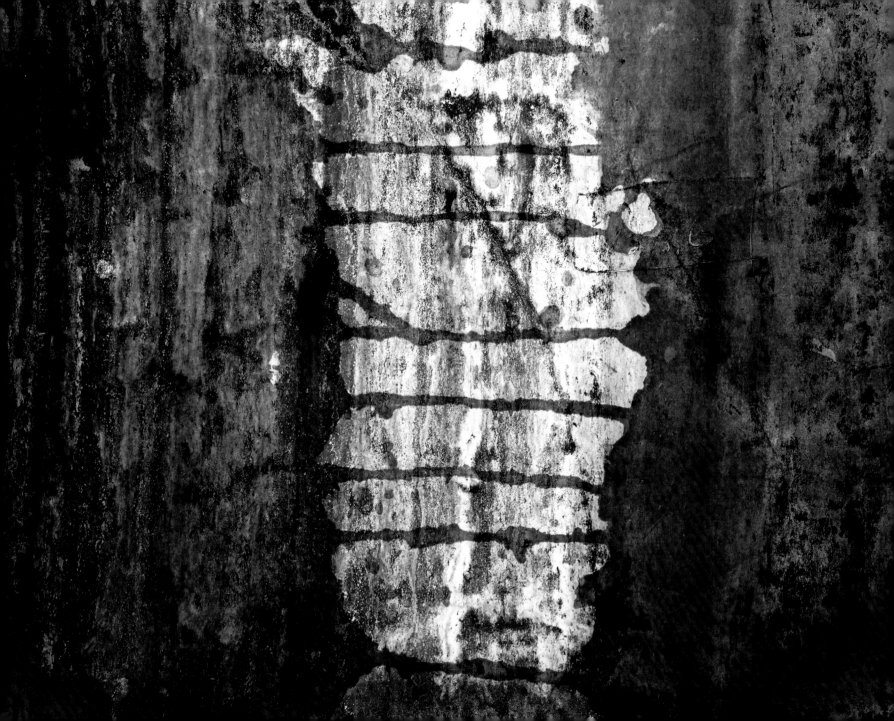

crow creates the earth

all animals then-
 bay, chestnut, flaming,
 foxy, reddish, sandy, [and
 gods, even- titian,
 rubicund)no going back once
 we have crossed
 and are entering in

a red letter day is surely for crow
day and night alpha to omega
the start to everything

 to paint the rich dark red,
 the sound of closing
 your eyes in the light,
 the umbilical and fruiting world

 to defy the dead
 to fly such a day

 oh redness of fruit,
 the redness is all
 the redness of red

particles

the light that fails
when we are lost
one to another

black holes trap every
thing in a shiver of time
the headwind of neurons

machines listen
when the particles rub and crackle
rumble like Milton's angels
all the way down

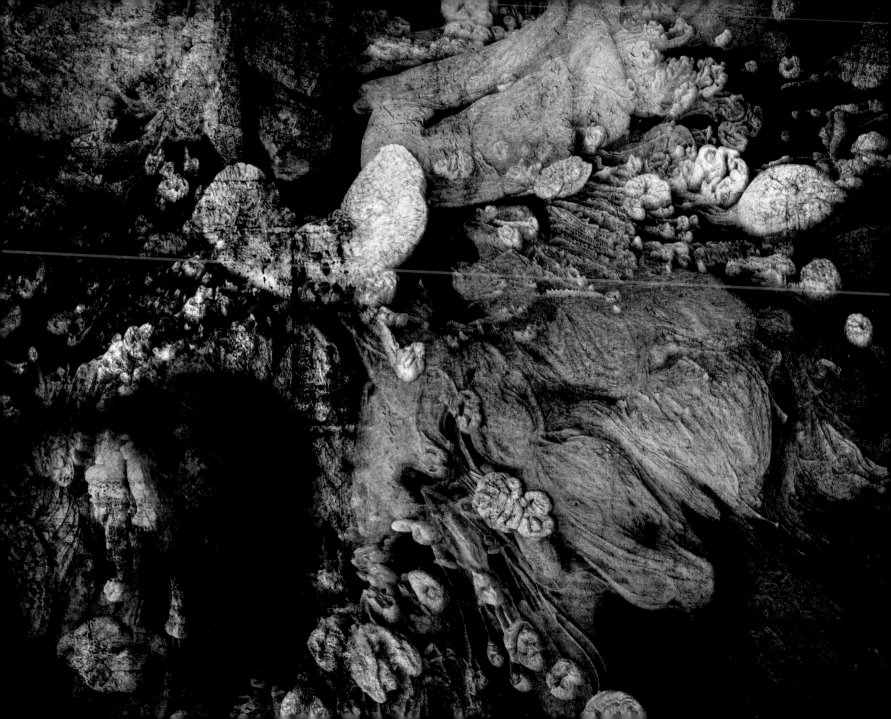

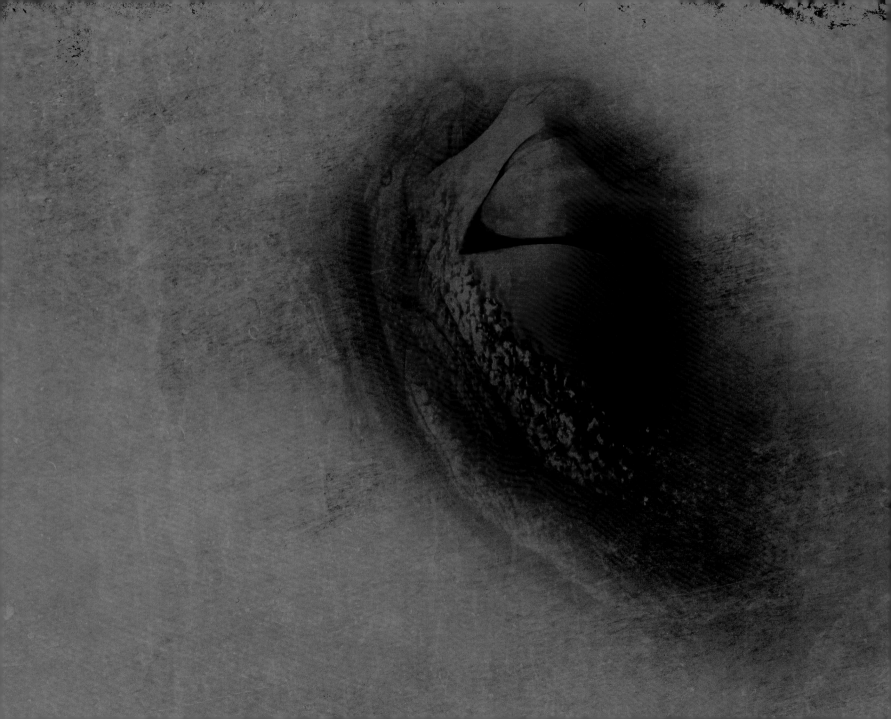

living without you

sleep-walking the chambers
in your heart which slapped
like a conveyor belt

when you stepped
 i listened
for the echo

 a doorslam
 until i thought
 you must die

how can i tell you
you have scraped my heart

iris

the light in the wood
is the grain the oil the sun
the glide of
light / shadow
shad

ow

\ sun
you always loved
morning & night moving across

the desk you sat at
aperture of your eye
opened & closed

light & dark in the video you held
an eye up to blow all the dust off
leaned over at night
dropped the pollen
bright as a vireo you might follow
all the way home

in the basement when they rub
the desk with the smell of lemon oil
light jumps from the oak

they have to screw it down
to keep all that light
from escaping

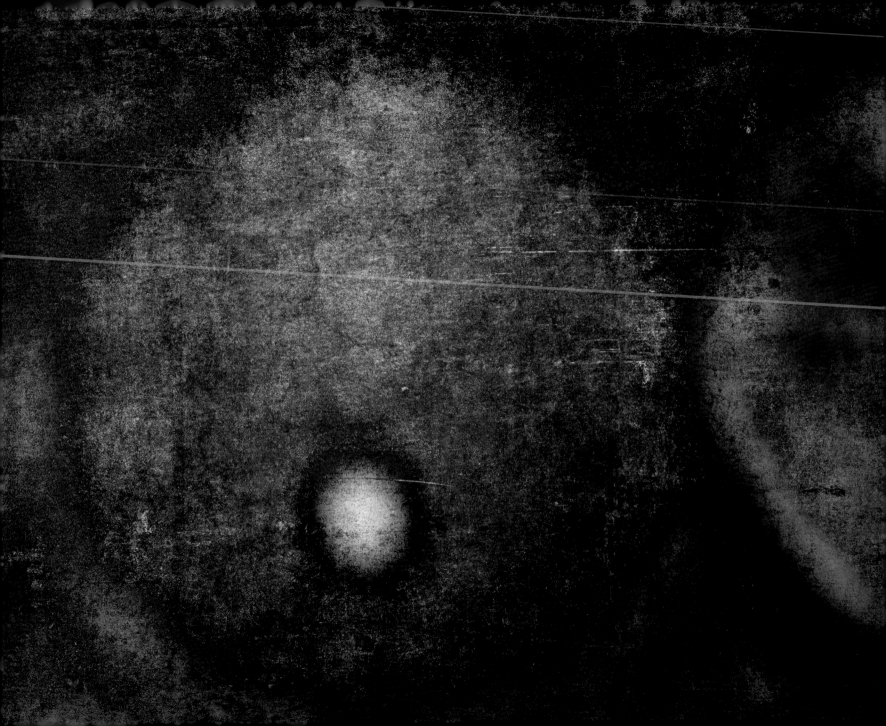

remember

the tears fish shed when they started
when first it started, everything began
they rose from the shale from the shade
cold weighing them down as if they
were timid as shale as ill timed

 where their eyes first broke
the Precambrian Shield, its huge shoulder
 & forests became

the silent seas crowded with saline
fish a silent film over their sight
what they see falls back through salt
their fossil eyes fill up from silt

they throw back light at us & in
that light i see you in the dark
sailing along as if you knew how
spearing fish in my heart
no mistaking it there it is again

a white streak, chalk on the black
boards we wipe clean night after night
a dim white figure moves
the dark at the heart of night

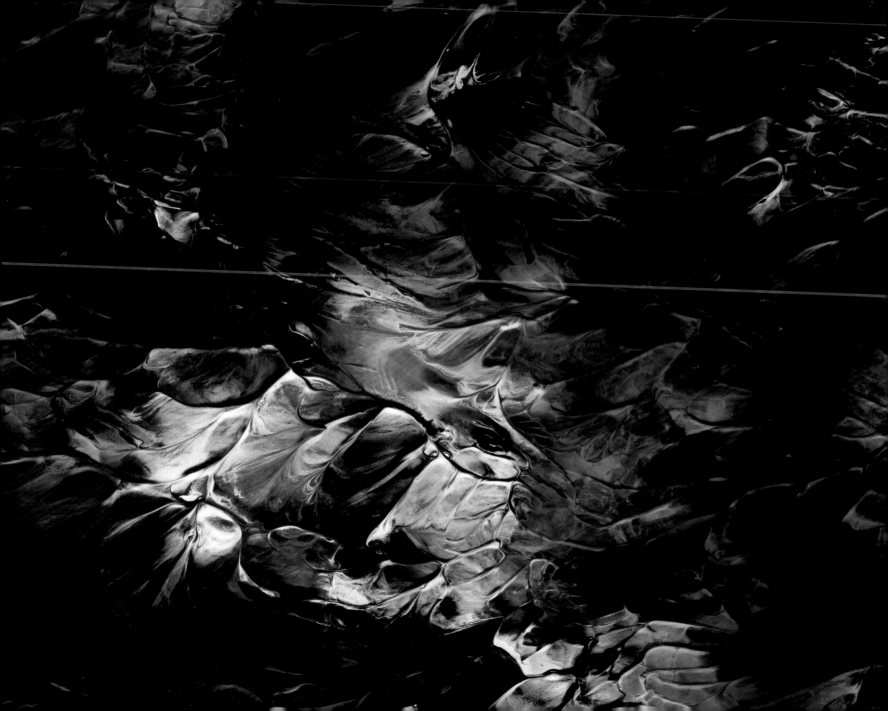

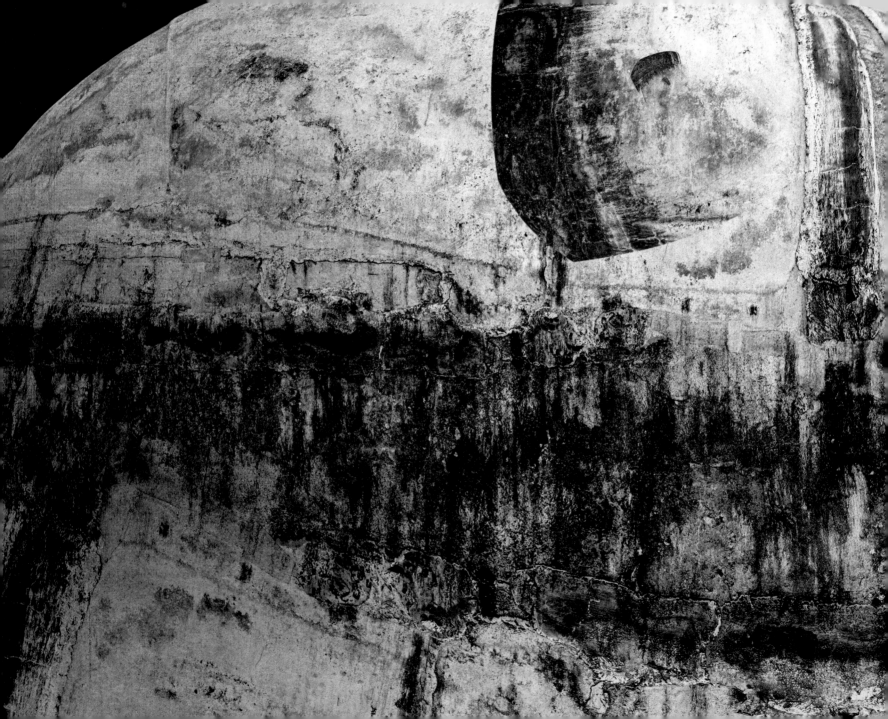

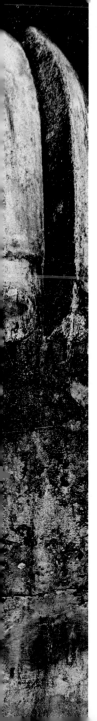

chimera

you have heard
the flies, the comma,
toes of spiders
their finicky lines
the lies we tell ourselves
and one another

the photograph we know
in cinema as sun-writing
its smears on eyes & walls

the shapes and colours
we lay in doodle and dabble
trick the mind or enable

writing you also
know is negative
that it in speckles struggles
to rise from the paper

to say what we would
say if we knew
what we thought
or what we thought
we could say
to one another

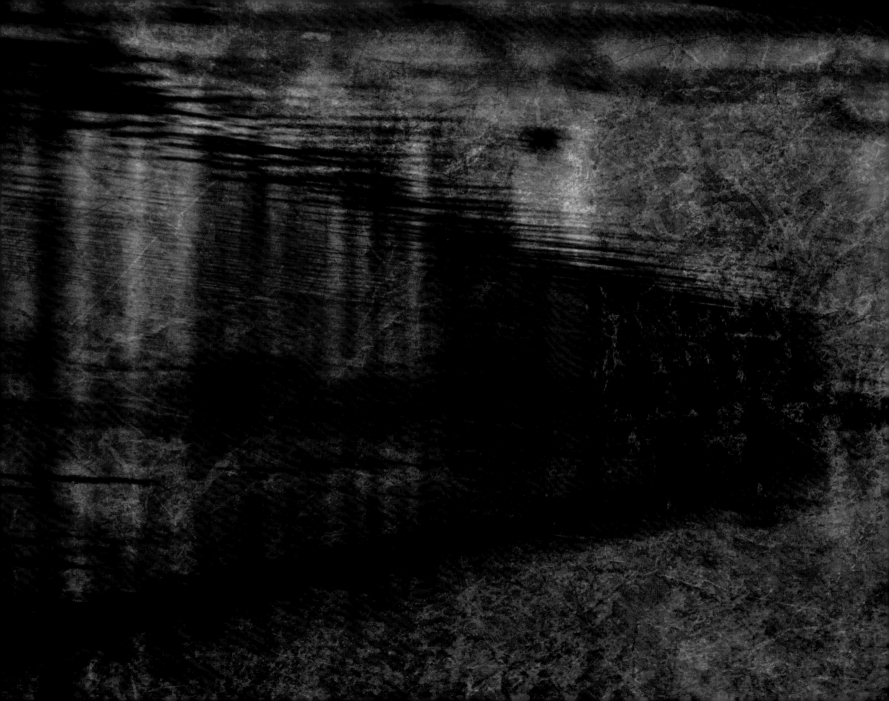

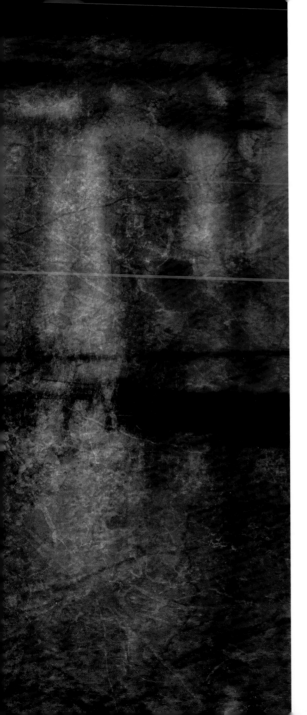

riding into sunset

a rag soaked in gasoline /set on fire
telephone wires, their hot intravenous music
the train follows into the night
 the crimson of travelling

 every evening
 the world explodes
and the blood runs down
 the rim of the world

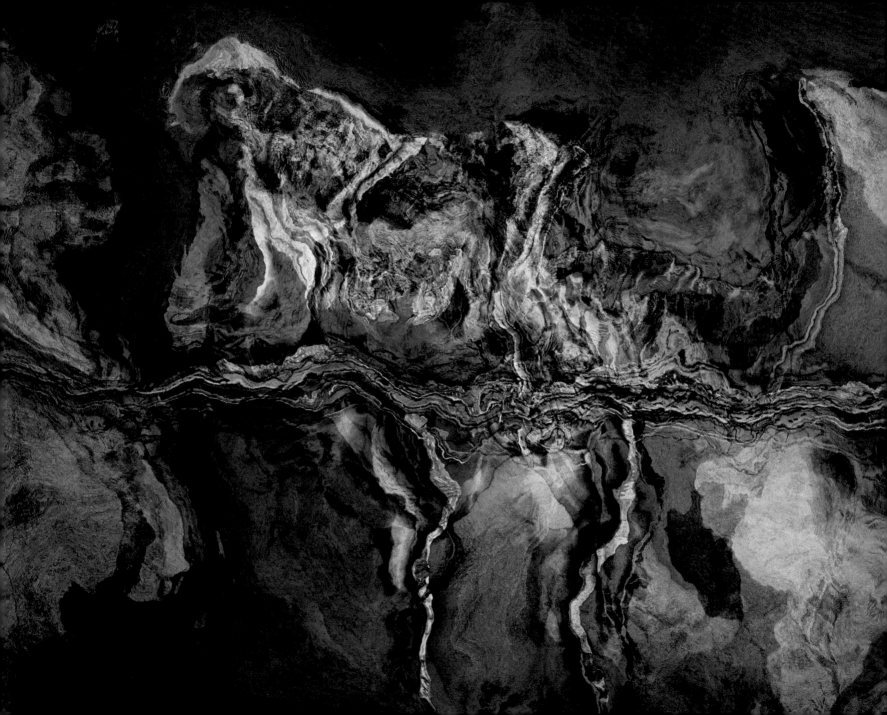

but then

when is there
 there is now
& there now will be
 when ever we
see after
 all that is
is all that
 now we were
when then was now
 & there was here
when we speak

there it is
 again when
it is new
 when we are
 there then
there it is then
 this is when
this is after
 just before this then

a wing, awing

an awning above the window
moon a daub of plasma
their eyes blue minerals at night

holding their damp palms out

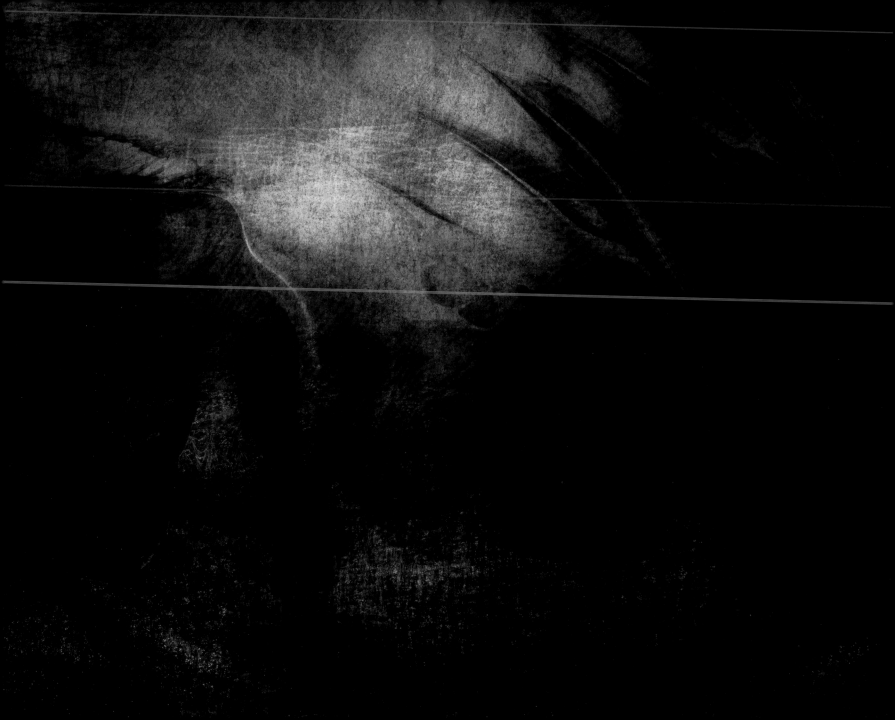

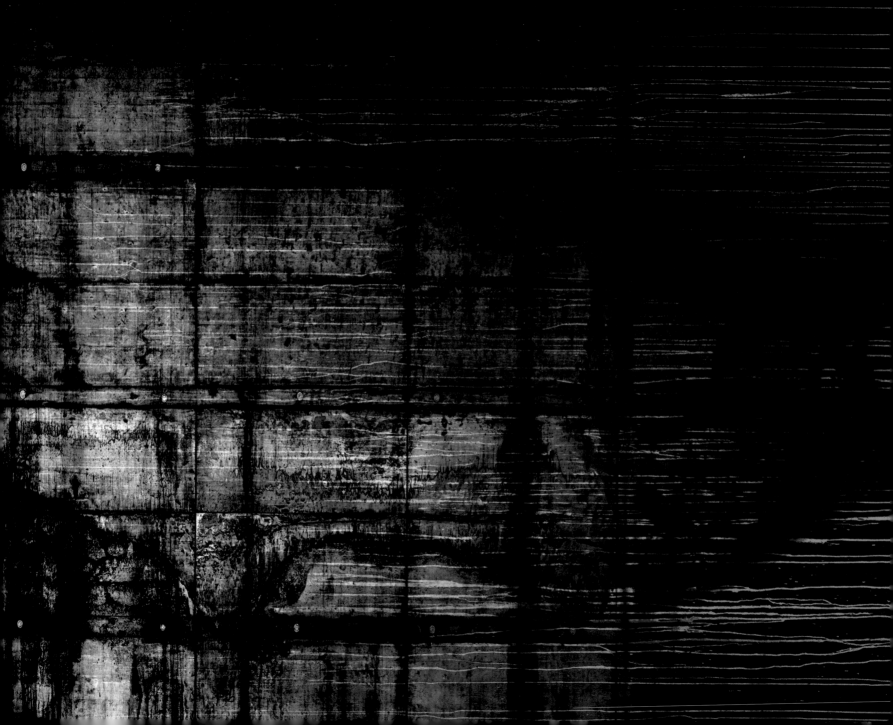

recovery

a darkness that un
winds the braids
from their belts
to cross off or
out the rumbling
earth grinding
to chaff and dust

people holding out
cups in their hands
spiders drop into

spiderwoman to
the rescue arachne
to his threads

someone to sweep on the bright lines
fling out & drop //
onto the spot.
swinging over and back

hhhnnn-hnhnn.

someone to join
the dots. acro
batically. someone to solve
crosswords,,, acrostics.

someone with an acoustic flair.
who could charm the very animals,
and in cross-stitches patch the world

we return

all our days

and beneath our gaze whales seals buffalo
migrate across great canyons
migraines in a cosmic brain
except for the beauty they sweep in

we weep have been away
have grazed the cosmos braided
light on darkness that fell upon us
lightning that days from heat let out

 we might touch the infinite
 charm of earth, gem, germ, garment
great doors closing and then opening filled with terror and love
blips of light small as decimals for this our earth some find dismal
our capsules were and our hearts contained & only final
winds and rain beneath us and we may be every second stars dying
 stars born in memories we orbit

a little crazed from an airless time
 -but we come back
flying and we are afraid
 novae boiling in distant beauty
 every second star moving to death or life

 in these our small and infinitesimal lives

Credits / Permissions

p. 138 "at the window" appeared in an earlier version in *Figure Ground* and is printed with permission from the Winnipeg Art Gallery.

pp. 86-7 "The whale captain's wife" appeared in an earlier version in *2º Encontro Internacional de Poetas Grupo de Estudos Anglo-Americanos Coimbra*, De 28 a 31 de Maio de 1995.

p. 146 "iris" appeared in an earlier version in correction line, and is used with permission from Thistledown Press.

p. 117 "night horses" appeared in an earlier version in *country music* from Kalamalka Press.

p. 76 "east of eden" appeared in an earlier version in *This Only Home*, and is used with permission from Turnstone Press.

p. 160 "we return" appeared in an earlier version in *This Only Home*, and is used with permission from Turnstone Press.

Acknowledgments

Michael

Special thanks to Therese, who is always there and always supportive. Many thanks also to the following people, whose perceptive observations and suggestions have been of immeasurable value in the development of all aspects of my photographic work: Therese Costes, Nathan Horton, Lance Keimig, Michael Kruscha, Chris Nicholson, Ludwig Rauch. And yet more thanks to my collaborator, long-time colleague and friend Dennis Cooley. The beauty and richness of your poetry continue to engender in me an endless stream of ideas.

Dennis

With thanks to the constant support of my family, Diane, Dana, and Megan. Particular thanks for the continuing reach of Michael Matthews' music and, more recently, for his dazzling art that drew me to this project and that is realized so brightly in it.

Both Dennis and Michael send special thanks to Matt Joudrey (At Bay Press) for his immediate interest and commitment to the project, and to Matt Stevens, Alana Brooker, and Priyanka Ketkar, who have also spirited the project through to the end.

Photo: Diane Cooley

Dennis Cooley has lived most of his life on the Canadian prairies, where for over 40 years he has been active as teacher, editor, poet, critic, anthologist, publisher, mentor, and supporter of writing. His work has been immersed in family, the prairies, and a play with form. His most recent titles include three books of poetry—*The Bestiary, cold press moon,* and *The Muse Sings.*

Inspired by the worlds of nature and literature, Matthews creates art that encourages us to step beyond the everyday, to dwell for a while in images of paradox, to consider the ever-changing tapestry of experience.

Matthews is active both as a composer and a photographer. He has recently completed a major song cycle, *Bloody Jack*. His abstract and night photographs have been exhibited in Germany and the United States.

In 2012 Matthews retired from twenty-seven years of full-time teaching at the Marcel A. Desautels Faculty of Music, University of Manitoba; he is now Professor Emeritus there. Matthews is a Fellow of the Royal Society of Canada and currently lives and works in Berlin.